ON THE ART OF DRAWING

Robert Fawcett

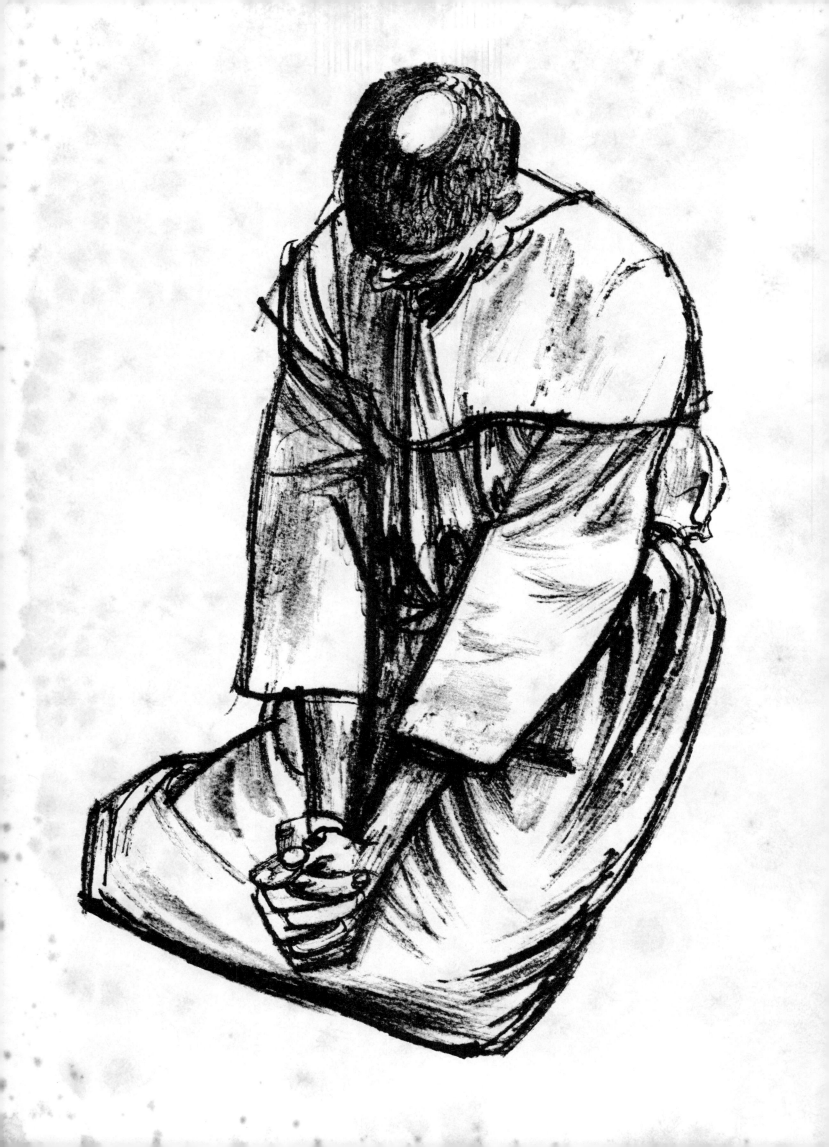

Robert Fawcett

On the Art of Drawing

An informal textbook with illustrations by the author

Watson-Guptill Publications, New York

Paperback Edition
First Printing, 1977
Second Printing, 1977

Copyright © 1958 by Robert Fawcett

First published in the United States by Watson-Guptill Publications,
a division of Billboard Publications, Inc.,
1515 Broadway, New York, N.Y. 10036

Library of Congress Catalog Card Number: 58-8130
ISBN 0-8230-3325-2
ISBN 0-8230-3326-0 pbk.

Manufactured in U.S.A.

To Agnes.

'Let this be plain to all: design, or as it is called by another name, drawing, constitutes the fountain-head and substance of painting and sculpture and architecture and every other kind of painting, and is the root of all sciences. Let him who has attained the possession of this be assured that he possesses a great treasure; . . .

MICHELANGELO.

Foreword

Very recently I was asked by a student to describe my own formal art training. I replied that it had consisted of only two years of drawing in life class. There had been earlier attendance at informal evening sketch groups, and as a child I had always been drawing around the home, but the only formal training was a two year period at the Slade School in London. The hours were long each day, the materials restricted to pencil and paper. During that whole time it could be questioned if I ever produced a drawing worth looking at twice.

My questioner was plainly skeptical; obviously he lusted to hear of profound courses in composition, perspective, painting and color theory. There had been none. At the time it did not seem that anything but drawing was necessary. Picturemaking or painting was something we believed would come by self-searching — by trial and error, later, or in the seclusion of our studios on weekends.

Concentration on drawing alone may have been less than wise, for some of the other skills did tend to atrophy, or at least wait. But this was common practice for many students at the time. We believed that only by drawing would we begin to experience form in the most direct way, and that form was the basis of all we would do later.

One may wonder how it is possible to learn about drawing (and some students did indeed learn and became quite fine draftsmen) without ever giving much evidence of it in class. I think it was because we were an earnest but inhibited group, and we never forgot that the Slade was the art school of London University. The mildest display of virtuosity in the life room would have been in extremely bad taste.

In retrospect one discards the necessity for much of that Spartan training but is still left with the conviction that similar results are difficult to arrive at by any other means. In the belief, however, that some groping can be eliminated, and much of drawing and the understanding of form can be explained and demonstrated, I embarked on the present volume.

I do not mean to make it sound easy. For a time I considered calling this volume "Drawing Made Difficult," to try to counteract the influence of the many books I have seen which promise the reverse. On the other hand, I don't think the study of drawing should be a chore. That it is so in many cases I attribute to a lack of understanding of the subject, often by instructors who themselves approach drawing as merely a tedious task.

I do not find drawing difficult except insofar as it constantly sets new horizons. That which has once been mastered does, of course, cease to interest. But this is what makes the subject a constant challenge.

I can be fairly sure that many of the ideas here will sound dated a few years from now. But this is not an attempt to define the last word on the subject. It is rather an endeavor to go back and investigate some of the first words. So long as it remains personal experience I don't think it can be challenged. Where an attempt is made to formulate a theory from that experience I imagine it can be, and, of course, will be.

That I am personally attracted to contemporary drawing does not lessen my regard for the work of the last several centuries. I feel no sense of time wasted in that I started out with one great idol — Ingres. In retrospect Ingres has assumed his place, but he has not been discarded because I have since looked more carefully at Picasso and others.

I have purposely avoided gimmicks which tend to lead the learning process away from the substance to be learned, and instead seem to be merely a method of painlessly attracting and holding attention.

This is a treatise and some random ideas on only one theory or aspect of drawing, illustrated by an author who happens to have spent a lifetime illustrating the literary efforts of others. It is probably one of the most difficult manuscripts I have been called on to illustrate, and at the same time one of the most rewarding because of the fascination of the subject. I have not seen many works on this

subject in which the author presumes to document his own text. Perhaps mine is a latent modesty which balks at having a humble text illustrated by every great draftsman from Michelangelo to Ingres. As is the function of illustration, the drawings should serve to attract the reader to a closer examination of the text and then send him back again to see if the argument has been proven.

Many of the drawings here are unimpressive. A few even date back to student days and were included for that reason. Others are frankly diagrams. However, interspersed through the book I have included many drawings which I happen to like and which may have little to do with the neighboring text. In fact some may think that they contradict the argument. I make no apology. Drawing is its own language, and the person of perception understands this.

I have purposely tried to select as examples those of my own drawings which help to convey the idea of how all-embracing the subject can be. Although content to start in the schoolroom, I have tried to move from there to the studio, to the living room and then to all outdoors. In this way I hope to avoid the tendency toward specialization which so limits the potential of many artists. I have never understood why some draw certain subjects superbly yet become frozen before others. An English artist who had just sat for his portrait by a colleague was heard later to stay "So and So has just painted a portrait of me, so I suppose I'll have to do a landscape of him" — which sounds very funny at first but less so the more one thinks of it. If the present reader finds a drawing of a figure beside one of a landscape, the object will be not to show how different they are but how similar.

Ridgefield, Conn.

We assume that no book of informal commentary, which this proposes to be, can produce artists, or even promote successful careers in the arts, if there can be said to be such things. The present volume aims simply to explore the subject of academic or classic drawing, to try to demonstrate what is demonstrable, to re-examine some ideas which may have become outworn. It is hoped to create a new respect for an aptitude which seems to have too few enthusiasts today, and to show the student some of that training which should precede painting. If my book can do this, and in addition wean some away from the long, long search for short cuts to a period of serious study, then it will more than have served its purpose.

I know that my belief in this need for a period of concentrated study at the outset is not shared by everyone. Walter Sickert, the English painter and teacher, is quoted as saying, "The student should from the first stroke of his pencil be making studies for pictures of his own." He said that "as the need arose for the study of a particular object the study should be made only as the hungry man might hunt a rabbit or spear a salmon for dinner." In short, he was against studying in what he called a vacuum, for the sake of abstract study — an interesting point but one which I cannot entirely subscribe to, for I believe that much of the technique of salmon spearing can be learned away from the stream and on dry land. If the student musician never played except in the concert hall we would be subjected to some queer performances.

The term *student* which is used throughout is to be understood in its broadest sense — that is, that we are always students, even those of us who occasionally stand up and pontificate.

Contents

pages 15-22 **1**

The Why of Drawing

24-33 **2**

Drawing for Information

34-45 **3**

Questions and Answers

46-59 **4**

On Drawing Naturally

60-64 **5**

On Technique

65-69 **6**

Variety in Drawing

70-75 **7**

Drawing as Understanding

76-81 **8**

Round or Flat

82-93 **9**

From Light to the Scene

94-101 **10**

On Taste

102-109 **11**

Seeing and the Medium

110-113 **12**

Economy

114-135 *Illustration and the Contrived Picture*

Table of Illustrations

page

(frontispiece) *Study for St. Stephen felt pen 1955*

15 *Child drawing felt pen*

17 *Susan pencil 1956*

18 *Chateau Gaillard Normandy felt pen*

19 *Figure study red chalk*

20 *Nude on sofa felt pen 1957*

21 *Street in Perugia felt pen*

23 *Seated figure pencil*

24 *Jill pencil*

25 *Exercise in form red crayon*

27 *S. Gimignano felt pen*

28 *Two figure studies felt pen*

29 *Page of studies felt pen and crayon*

30-31 *Figure studies in repetition red crayon*

32 *Female with towel felt pen and white chalk*

 Study of child felt pen

33 *Mother and child casein tempera*

35 *Figure in patterned skirt ink*

36 *Figure study felt pen*

37 *Seminude with towel felt pen*

38 *Reclining figure white chalk on gray*

39 *Reclining figure pencil*

40-41 *Figure studies felt pen and white crayon*

42-43 *Figure studies red crayon*

44 *Workers felt pen*

45 *Male figure studies felt pen*

46 *Reclining nude felt pen*

48-49 *Diagrams drawing sight size*

50 *Diagram felt pen*

51 *Rapid gesture drawings felt pen*

52 *Rapid gesture drawings felt pen*

page

53 *Rapid gesture drawings charcoal on newsprint*

54-55 *Rapid gesture drawings felt pen*

56-57 *Figure studies with emphasis felt pen*

58-59 *Male figures in action felt pen*

60 *Sketch near Arles felt pen*

61 *Model with cigarette pencil and wash*

62 *Child's head pencil*

 Lord Russell, from TV screen felt pen

63 *Bronze head of Apollo Nimes felt pen*

64 *Figure study felt pen*

65 *Nanette pencil*

66 *Preliminary sketch felt pen*

67 *Roofs Assisi felt pen*

68 *Chapel near Arles felt pen*

69 *Reaching figure brush and ink*

70 *Boat yard Norwalk felt pen*

71 *Standing figure felt pen*

72 *Life study felt pen*

73 *Reclining nude mixed media*

75 *Figure study pencil 1957*

76 *Sketch of boy pencil 1923*

77 *Life class drawing 1924*

78 *Sunlight through trees Nimes felt pen*

79 *Abandoned abbey near Arles felt pen*

80 *Portofino felt pen*

81 *Sunlight S. Gimignano felt pen*

82 *Figure on sofa London 1957 felt pen*

83 *Figure in landscape — Figure in interior*

85 *Coon Ledge, Connecticut felt pen*

86 *Seated nude*

87 *Seated nude by window London 1957 felt pen*

page

88	*Kneeling model with sunlight felt pen*
89	*Hotel window on a court Paris 1957*
90-91	*Diagrams felt pen*
92-93	*U.S.A.F. troop movement felt pen*
94	*The Seine Normandy felt pen*
95	*Figure study with drapery felt pen*
96	*Woman felt pen*
97	*Gina charcoal 1945*
98	*Model reading felt pen*
99	*Betty pencil 1924*
100-101	*Automatic drawings pen and crayon 1945*
102-103	*Flower studies Queen Anne's lace felt pen*
104	*James Fitton, R.A. pencil 1923*
105	*Sansevieria felt pen*
106	*Drawing from a Greek vase pen and ink*
107	*Figure drawings in soft line felt pen*
108	*Paris from hotel window felt pen*
109	*Paris from hotel window pencil*
110	*Figure drawing line*
111	*Boat yard line and white crayon*
112	*Chapel near Arles 1957 felt pen*

page

113	*Assisi felt pen*
114	*Preliminary drawing*
115	*Preliminary drawing felt pen*
116	*Final preliminary red crayon*
118	*Preliminary study pencil*
119	*Study for illustration felt pen*
120	*Preliminary drawing felt pen*
121	*Vignette studies felt pen*
122	*First sketch and drawing in progress ink*
123	*Finished illustration ink and wash*
124	*Study for single figure*
125	*Composition study and finished drawing*
126	*Composition plan*
127	*Composition plan and finished painting*
128	*Beethoven study for painting felt pen*
130	*Preliminaries for painting*
131	*Final drawing and finished painting*
132	*First sketch for illustration felt pen*
133	*Second sketch for illustration*
135	*Lincoln at Gettysburg pencil*

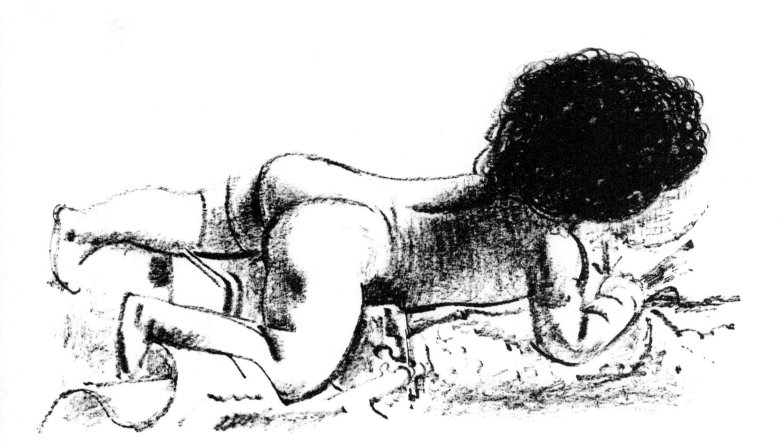

1. *The Why of Drawing*

The word *drawing* seems to be one that all professionals and students use freely, but which no two ever seem to use in quite the same way. It is obvious that a new book on the subject, in a field already crowded, must consist of more than a collection of plates demonstrating the author's versatility. It must also be more than a collection of fine drawings of the past and present, for though the study of these is almost mandatory, the books of reproductions are many and, without demonstration, too many fail to see the pencil and chalk studies of the old masters as applicable to their present-day problems. They end by paying lip-service to excellence without delving further into it. Furthermore, the trends of contemporary painting seem to by-pass draftsmanship as a means. The fact that a nonrealist or semirealist like Picasso started by drawing in a way which resembled Ingres is laid by some to the inexperience of youth. Actually

Picasso to this day starts with careful, rather realistic drawings, which he later overpaints and "destroys" in his own word, as his study of his subject deepens and progresses.

The reliance by many painters and most illustrators today on the photograph as a substitute for drawing shows a lack of understanding of what the ability to draw means. These two have nothing to do with each other. They are not in conflict because there is no similarity of purpose. It will be one aim of this book to show that the study of drawing can be a release to the imagination and not, as photography sometimes is, simply a realistic documentary aid.

If parts of this book seem to stress constant and what might be called relentless drawing it is only because it seems time today for an application and devotion which the student may up to now have congratulated himself on having dodged. I know of

no way to avoid this completely if the desire is to become a draftsman in the sense of building a confidence that nothing visible or imagined is beyond one's ability to record on paper. This, it seems to me, is the ideal to be attained. And what holds the imagination back more than anything else is sloppy seeing. We must *see* first, then we may safely imagine more; vagueness and blurred seeing are not the same as inspired transformation of reality.

Sir Joshua Reynolds in his address to the Royal Academy students in 1769, told them this, "The error . . . is that the students never draw exactly from the living models which they have before them. It is not indeed their intention; nor are they directed to do it. Their drawings resemble the model only in the attitude. They change the form according to their vague and uncertain ideas of beauty and make a drawing rather of what they think the figure ought to be than of what it appears. I have thought this the obstacle that has stopped the progress of many young men of real genius; *and I very much doubt whether a habit of drawing what we see will not give a proportionable power of drawing correctly what we imagine.*" (Italics mine)

There are those who contend that this kind of study is outmoded today, that the modern artist develops somehow by himself and without formal training. It is suggested that the development of the student's intuitive perception is gravely retarded by what are sometimes referred to as the "clichés" of seeing. The vague and indefinite scribbles of the beginner are too often hailed as rare flashes of insight which will forever be denied the patient searcher. The ability to draw well, we are told, is something to be unlearned.

It would be a matter of concern if this were true, but it is not. The keen eye which looks in wonder and appreciation at how things are, soon develops that humility which precedes the gaining of knowledge.

The reader may notice some seeming inconsistencies as this volume progresses. They are perhaps not really so. The reason for this is that what is right and useful advice for a beginner is not necessarily so later for a more mature artist with some experience, and I have tried to keep the study of drawing in some sort of logical sequence. If one is still mildly confused by these occasional contradictions, then the happy time may have arrived for him to make up his own mind, and eventually to put all books like the present one into the discard and strike out on his own.

I occasionally experienced a similar difficulty in making some of the drawings which illustrate this volume, in trying to draw in a manner which is no longer natural to me, but which was the best I could remember doing as a student.

Learning to draw is more than learning to draw the human figure — theoretically one could become an excellent draftsman after years of drawing only eggs or apples. Yet many demonstrations in this volume are from the figure, and in making them I have accepted the convention of the life class and the nude as a point of departure.

The study of anatomy is purposely ignored. I seem to remember studying anatomical diagrams as a student; I even attended medical school and watched dissections for a short period. In urging now that the student leave anatomy to the surgeon, I mean only that it should not become the substitute for the penetrating and discerning eye. The study of anatomy will in any case be forgotten by the developing draftsman as soon as the more exciting aspects of drawing begin to manifest themselves to him. Anatomy should be dropped when it starts to interfere with that new, fresh look, that deeper insight and understanding which are the hallmark of the draftsman. Our instrument is the eye, not the scalpel.

The same, I think, is true of perspective. You may study this subject until the glad day when your picture, which you know is correct in terms of that science, begins to look incorrect and dull to your knowing eye. The time has then come to discard perspective and rely upon the trained senses, one of the uses of which is to reveal the truth in what may seem superficially untrue. As a matter of fact, we are always dealing with illusion so that the question of "right" or "wrong" should not enter our discussion.

It is possible to divide the subject of drawing into two broad classifications. The first is drawing as preparation for something else, for paintings, for more complete realization of plastic ideas. These are studies. The second is drawing as an end in itself, as a complete art form. The former will be more diagrammatic; it is the kind of drawing which I think can be demonstrated. The second is more difficult to define, for there are no limits to the fancy or to the imagination. The appeal of this kind of drawing is aesthetic, and the response should be pure, uncritical pleasure. It cannot be taught. It is complete and final and subscribes to no rules. For this reason we will not

Susan

be concerned with it, except to be cautiously aware that it can refute every word ever written on the subject.

A Chinese epigrammatic poem contains the line "He who values a picture for its resemblance, has the critical faculty near to that of a child." The Chinese knew of that higher form of aesthetic pleasure than the mere recognition of facts. However, the writer goes on to say "Art produces something beyond the form of things, though its importance lies in preserving the form of things." Mr. Bernard Meninsky, draftsman and teacher, sees in "this seeming paradox the key to the mystery — the great draftsman preserves a form whilst endowing it with a sense of infinity."

But while a good drawing is an informal revelation

of the artist's basic vision, a textbook like this must limit itself to what is demonstrable; that is, the artist's outer vision, the simple acts of seeing, understanding, and recording. I own one volume on this subject by an excellent artist, illustrated with particularly good examples of his fine, sophisticated drawings. But he is a mature artist; the drawings contain much that is imaginary and inventive. The student could easily be baffled when confronted by these examples because he cannot see the same things in the model. If his admiration for the artist's style is great he may be tempted to imitate the surface mannerisms, and the result will be an affectation. That is why many of the illustrations in this present volume are as diagrammatic as possible, as close as possible to what the normal eye sees.

For our purpose it would seem best that we think of our job only as the development of an aptitude, otherwise we are soon going to be out of our depth. In the end it will be only by arbitrary limitation that we can confine it to that. But we shall try to remain in the realm of things demonstrable. We should, in fact, be able to prove what we say and avoid merely voicing preferences.

To become a professional requires training. Training begins in the simplest way; that is, by learning to draw. To some, drawing is looked upon as a necessary evil. It should be pure pleasure instead. Training does impose a discipline, as does any schooling, but that is no reason why it should become a dull routine. To train one of the senses should be a joy, even if it involves a certain amount of repetition.

It would, of course, have been nice to confine this discussion to *pure* drawing, without reference to how the aptitude will be used. But it is useless to deny that many students of art begin by preparing themselves for a particular field. Insofar as they do this it seems to me they limit their own potential, but since it is the case we might explore the reasons for it.

High on the list of the applied arts is so-called graphic art, illustration in particular. For this reason I have included at the end a section on the application of drawing directed specifically to the illustrator, for good illustration demands a particularly high degree of draftsmanship. But during the argument we will try not to single out the illustrator for special consideration. Suffice it to say that it is impossible for him to draw too well. If a student illustrator fears that he is on the way to achieving a greater aptitude than he will ever need to employ, he is almost certainly wrong. As we have said, greater knowledge will result in a better illustrator (though, perhaps, under commercial conditions, not necessarily a happier one). His drawings are not likely to display dazzling feats of draftsmanship. They are much more likely to be characterized by the restraint of self-confidence. The artist who has resources does not need to announce this fact from the housetops — it will be apparent.

Later if he feels that the restrictions of illustration limit his expression he will either call upon his greater knowledge to enrich and prolong his development and career, or else he will take time for self-exploration. In either case he cannot lose, and he should therefore approach drawing as an art form in itself, as should all who love the medium.

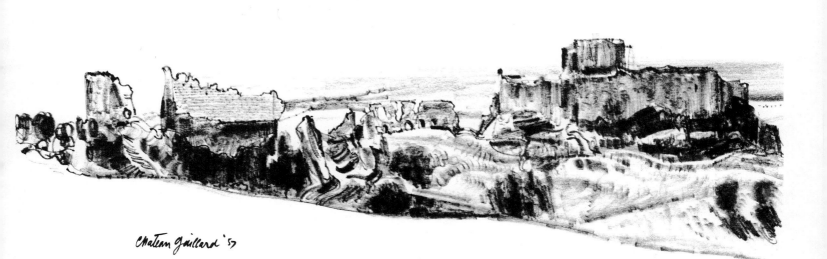

Château Gaillard '57

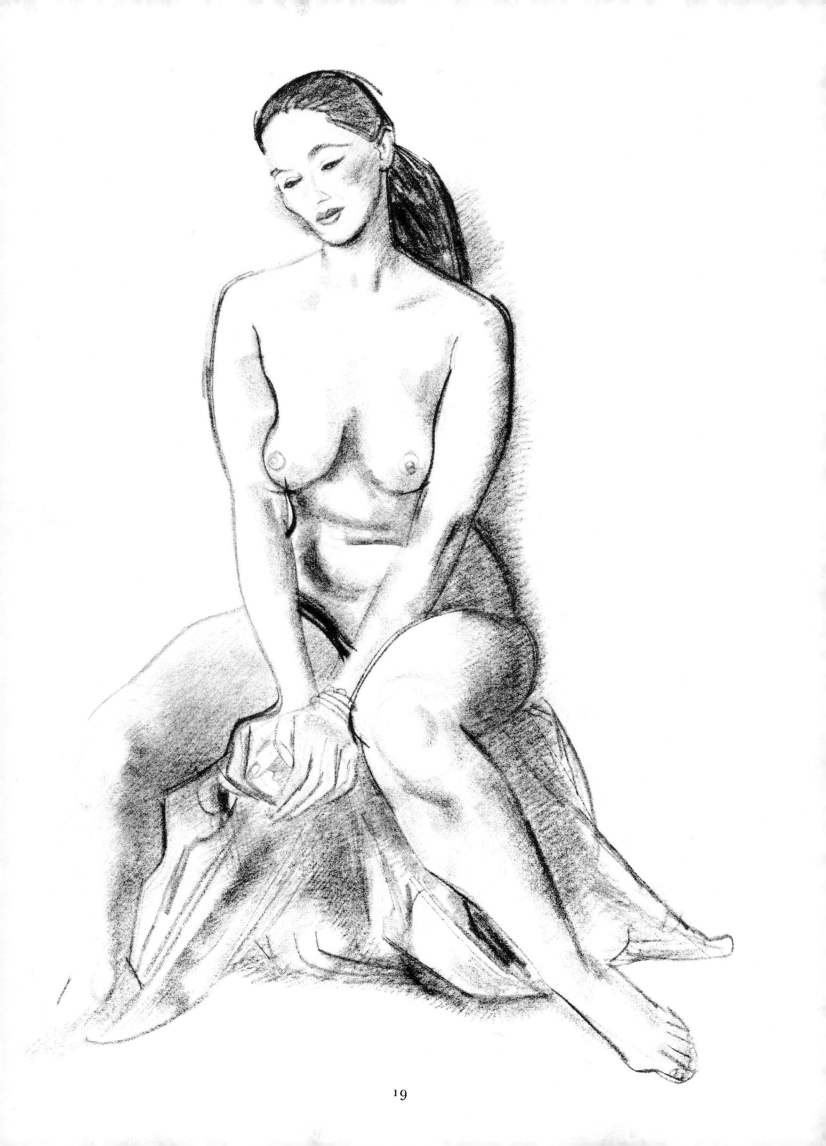

We said that good drawing deals with understanding. Understanding of drawing is best brought about by absorption, by constantly looking at other drawings. By studying, appraising, and analyzing, one develops a set of standards which begin to satisfy and enrich the experience. Of course, this is not inevitably the case. I think it was Whistler who once said, "a life spent among pictures does not necessarily produce a painter; otherwise the policeman at the National Gallery might begin asserting himself." The policeman in question inevitably looked over the pictures, but not at or into them. (Neither, in fact did most of the visitors to the gallery it was his job to guard.) But the fact that the experience of most gallery visitors is superficial does not mean it should continue. We grow in understanding as naïve standards give way to more sophisticated ones. These steps in growth are too often accompanied by a complete rejection of that which only yesterday commanded our admiration. A more mature step occurs when we return in retrospect and see both in truer perspective.

The violent likes and dislikes of youth, especially of the art student, are typical. Later, one never again has the temerity to accept or condemn with such vehemence. The trouble is that without experience, superficial efforts are often considered important, and technique is often confused with content. Yet I doubt whether this can be avoided just by reading on the subject. Drawings are too often categorized as academic or modern, serious or superficial, fine or commercial, whereas the only standard worthwhile is whether they have meaning for the individual, and what kind of meaning it is. One would have thought that the recent elevation of Daumier, the prize cartoonist of his day, to the ranks of the great artists might make some of us pause before the too ready evaluation, but it rarely happens. In New York City art on Fifth Avenue is 'fine'; that of Madison and Lexington Avenues is 'commercial,' and having neatly pigeon-holed the distinction, we no longer feel the need to give it any further thought.

I suppose the plea I am making here is for the open mind, for the courage to hold values and express opinions which may not be the popular ones. Also it is possible for worthwhile drawings to appear at unlikely times and places. Without an open and therefore receptive mind one will not recognize them when they do.

The English painter Walter Sickert, friend and contemporary of Manet, Degas, and Whistler, once said, "If we allow ourselves to ask who was the greatest English artist of the nineteenth century it would be difficult to find a candidate to set against Charles Keene, a draftsman on a three-penny paper." Unfortunately Charles Keene was dead for many years before this opinion became the accepted one.

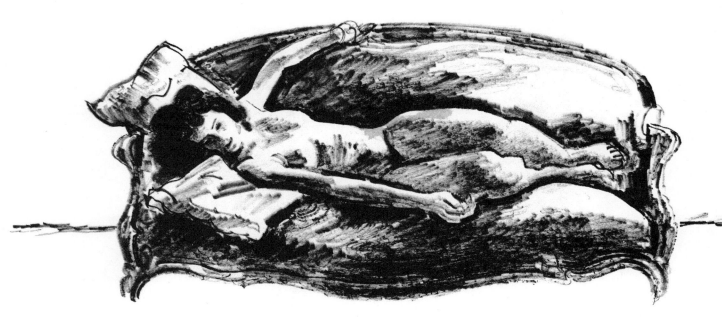

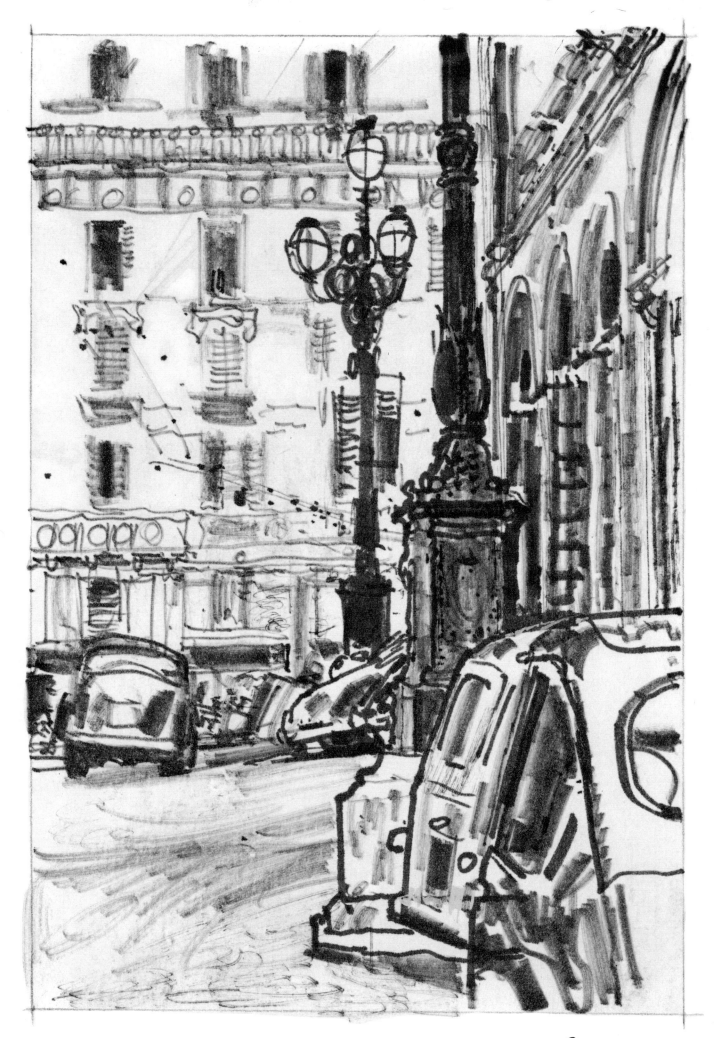

Perugia '57

Why do we draw? We draw, I suppose, because it is one of the most primitive and natural human instincts. Some thousands of years ago we would have drawn on cave walls records of the animals which the more virile members of the tribe had stalked. There is hardly a child today who, before the age of reason, does not reach out for the colored crayons to record his first visual impressions, and later his first imaginings. And drawing should come as naturally as that.

When we ask a question of the scientist, in all probability his answer will be a mathematical equation. But ask a technical question of the average artisan — a plumber or a carpenter — and out will come that blunt stub of pencil, and the tortured attempt to make clear to us in diagram a point which it would be impractical, if not impossible, to put into words. The artist and student should approach drawing with the same kind of determination.

We can become bored by a verbal description of a landscape, whereas a drawing or painting of the same subject might charm us. A description of a figure would quickly exhaust the average vocabulary, but a drawing informs us immediately. We are inclined to pass rapidly over the novelist's description of the physical properties of his characters, whereas the illustrator's picture is designed to entice the reader into the story.

When I draw a figure I do so to make an imaginary onlooker aware of its general visual aspects, if I am unskilled — and of its particular visual aspects if I am trained. And this is only the beginning, it applies only to the figure in being — engaged in no particular activity. Add gesture, expression and behavior, and we are embarked on an exercise of no mean complexity. The sophisticated and trained artist is drawn to his subject by an interest about which he wishes to comment graphically. The degree of his capacity will control the subtlety of the graphic description. That is why I think the artist should submit to the discipline of formal training no less than any other skilled professional. There is too much which is already known to risk the embarrassment of rediscovery, and until we exhaust this vast area we are not in a safe position to make our original comment.

The ultimate clarification for the student will come by practice, not by reading words or listening to argument.

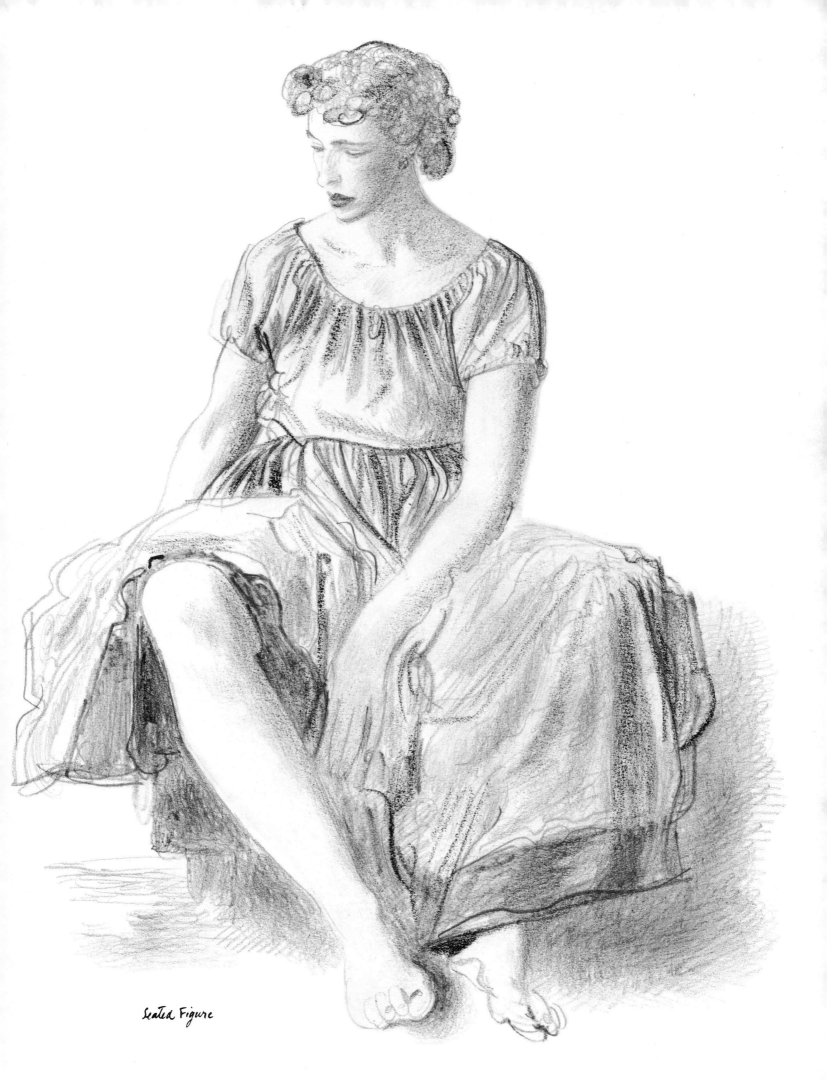

Seated Figure

2. *Drawing for Information*

Painting and sculpture, the two major plastic arts, differ in that painting creates the illusion of depth on a flat surface, whereas in sculpture the depth is actual. The painter thinks and works in the flat; the sculptor does so three-dimensionally, or in the round. This difference is of fundamental importance to the student of drawing if he is to know what he is doing and why.

There are, of course, exceptions. The first and most obvious is Michelangelo, whose studies for painted murals or sculpture are almost identical. These are primarily sculptor's studies, because Michelangelo was first and foremost a sculptor. He considered painting a medium for lesser talents. When he did paint, for example, the decorations of the Sistine Chapel, they were, in effect, paintings of sculptured figures. In his drawings and studies for these murals one sees him molding the form, emphasizing its muscularity, rotundity, and bulk, as though his hands were full of clay rather than holding a piece of chalk or a point.

Most early painters had one primary aim, which was to take from the model the maximum of information, to make their studies as eloquent as possible, so that little data was missing when they painted, as they often did, from pencil, chalk and ink sketches made previously. In Holbein's portrait studies, for instance, it is impossible to see what more could be added by way of penetrating delineation of character. That his sitters demanded painted portraits, and that he could make them, was, to a degree, irrelevant. The fact remains that he had such an accurate eye, so trained and obedient a hand, that his drawings contained all (and more) information than he needed to paint from. We can say this despite the knowledge that he sometimes employed crude mechanical aids.

Skill in recording information will later be one of the tests of the artist's success before the model. If he should take out today's study a week or a month later and see how much information it contains which could be translated into another medium, he would then be putting it to that test. Will it be a bare approximation of the subject, vague marks on the paper, or will it be a document containing valuable data on form, shape — almost color? Is it information about the *particular* subject which was under observation, or is it merely general information which would apply, say, in the case of a human model, to any figure?

When a student focuses on these possibilities his attention will be given urgency and direction, he will learn to employ more purposeful and searching observation.

But it may also be said that although the primary aim of graphic art is to convey information, very often a transformation takes place. The object described is found to have aesthetic significance, to be imbued with values beyond the merely descriptive, similar to that which happens when words used originally for purposes of a strictly utilitarian nature, are lifted into the realm of poetry.

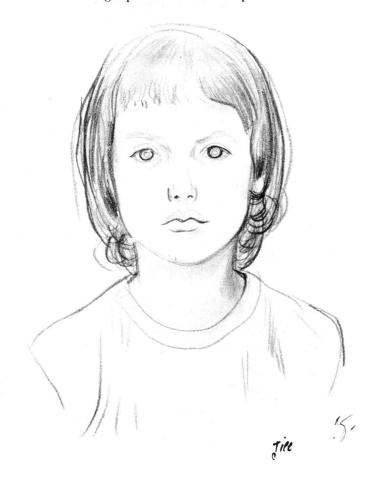

Jill

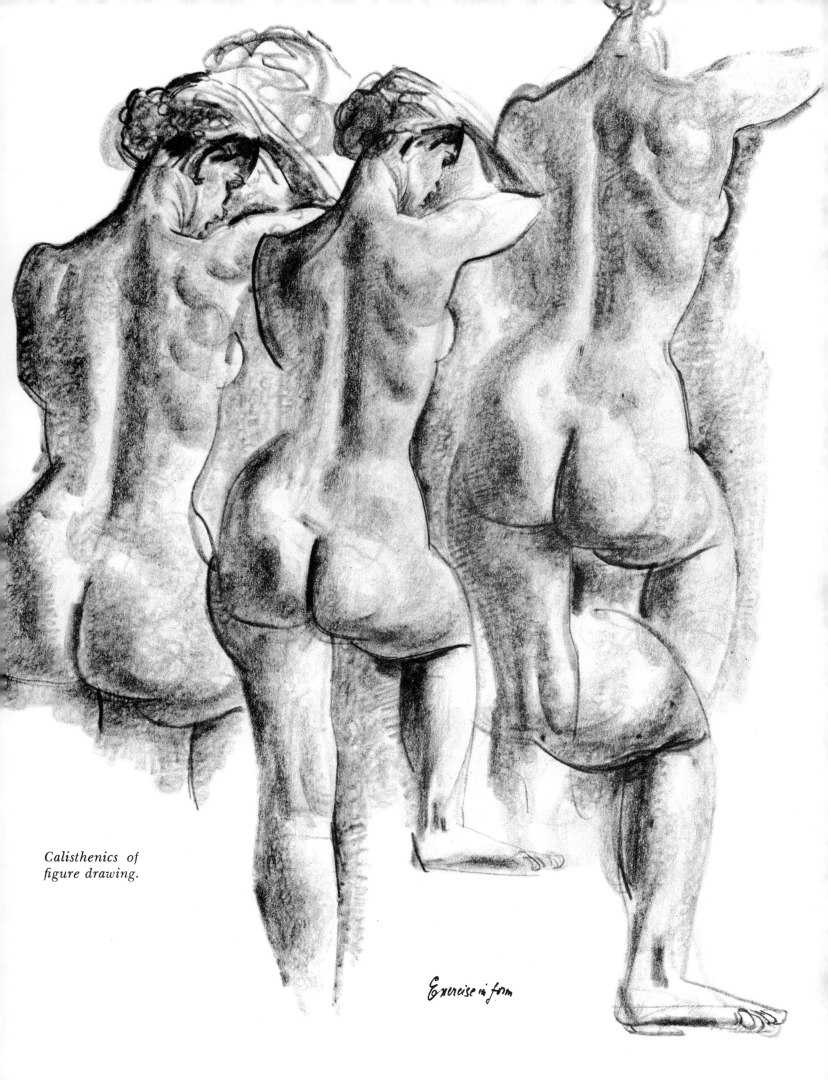

Calisthenics of figure drawing.

Exercise in form

Drawing for information inevitably calls for the sustained study, and it is at this that many students balk. It seems like old fashioned academic procedure. The resultant drawing often becomes smudgy and sweaty, overworked and dull, in fact nothing to take home and frame. But this is how it should be.

The sustained study is more than a quick impression, more than the lightning flash of recognition. It is worked over until it is felt that everything seen has been stated. In a way it is a test of endurance, this time of one's powers of observation.

One knows it is time to stop when the faculties are no longer alert, when one becomes dizzy at trying to see form which is constantly elusive, and when it is obvious that what is taking place is not drawing but mechanical copying. That is the time to stop, but only to stop that particular study. The same experience tomorrow should come more easily.

I believe this to be the part of traditional practice which is good, unhampered by too much anatomy and other dogma, content instead to train the powers of keen observation. Art is no more a natural aptitude than athletics, and whatever modicum of natural talent there is must be nurtured by training. I bow to no one in my delight at seeing natural drawings by children, but I often wonder what happens to so many of the painting tots after the age of ten.

Remember we said that many of the old masters drew to paint from later, and that the information they put down was dictated by tomorrow's need. The drawing was a document. The student does not have this fortunate need, and time is usually no problem. The model or the object will remain still all day and can be subject to the most probing observation.

But now we are discussing and even advocating quantity of information at the expense of selectivity and emphasis. We are out on a limb in seeming to say that a high degree of finish is a good thing in itself. The answer I believe is that *it is good at this time*. The shorthand, or calligraphy, when dictated by a transient subject or other technical limitation will come more easily after the concentration demanded by sustained and complete studies. Admittedly the spontaneously economical drawing — the quick study of the child who won't keep still — often has great charm, but the latter is a quality to beware of. After a while you may find yourself striving for it — and in doing so it

becomes an obnoxious mannerism. I have never considered charm a very valuable social quality, but I do notice its true presense most often in those totally unconscious of possessing it. The same goes for drawing.

The sustained study will be made easier by following certain specific advice which I shall try to document. Meanwhile, at the risk of coining a phrase, remember that everything is relative — the study will be made more or less convincing and successful by a careful comparison of the relationship of every observation to that one adjoining it. The understanding of a form is aided by the comparison of each of the edges which bound it. The angle at which forms take off is decided by comparison to an imaginary vertical. One models until things which look round and solid begin to look round and solid on one's paper. If a line is incorrect, we should not erase, but merely put down the correction as a reminder that the discrepancy was noted, and proceed with the drawing.

It is often useful to draw, or at least to observe, the shapes left by things. One sees through the space contained by arm and torso, and the observation of what its shape is will aid materially in correcting inaccuracy in the form itself. But a corrective aid is all this is, until later when we start thinking and drawing by pattern.

One should try, although at this stage it is difficult, to carry relationships still further; that is to see each detail only in relation to the whole. The total impression is the end toward which we are working and the more clearly we try to see it the more likely are the parts to fall into place.

Most important as discipline is carrying the study through to the bitter end. I know well the tendency to avoid delineating that foot which "doesn't draw well," or those hands which "are interesting but might not come off, so why spoil the drawing" and we leave them only indicated. But that is self-indulgence — something else to beware of.

This is the blood, sweat, and tears of learning to draw. You'll be a better man for it, as well as a better artist.

It is this stage — the searching, sustained study — that too many students seek to avoid, and that too many schools fail to insist upon. I call this part of the calisthenics of drawing. If you can see a parallel in sports it becomes easier to understand. It is to gain that extra stamina one may never be called on to exercise, but which it is comfortable to have.

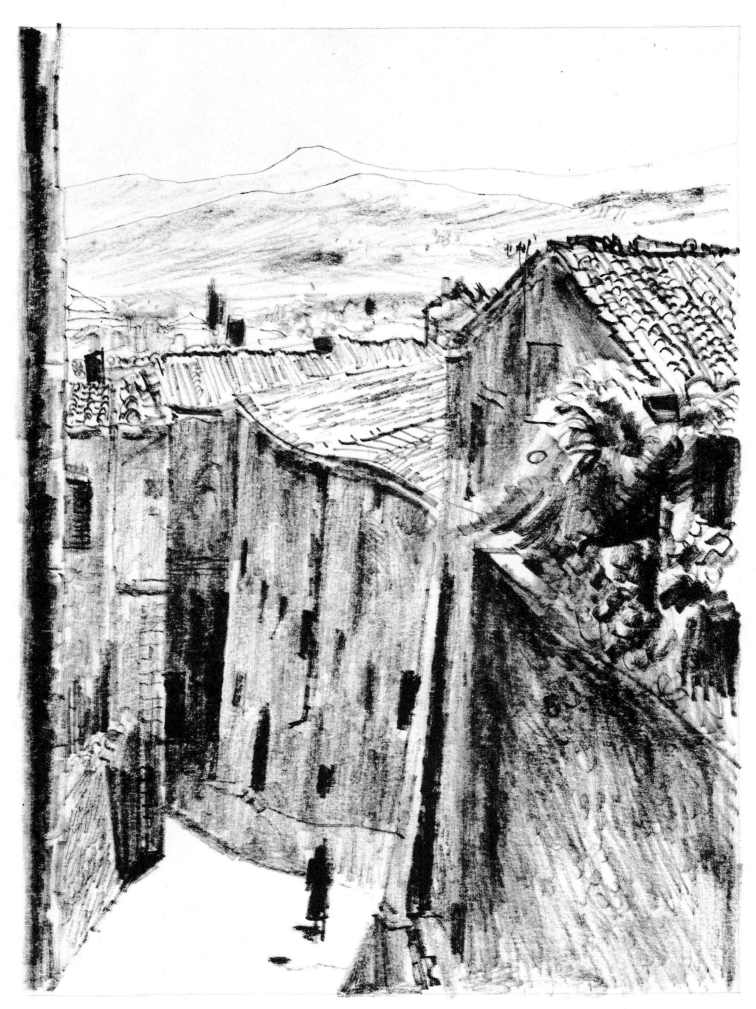

S. gimignano

It will be found that the same subject — after a period of penetrating observation — can begin to take on different aspects. It is what I described as becoming dizzy with looking. The sustained study is much harder than recording the first impression or the general aspect, and is such a tiring exercise that, where it is practiced, it is usually followed by a more relaxed and perhaps stimulating period of rapid gesture drawings. It is preferable to have these follow immediately, so that the eye and hand which have been subjected to one discipline, find release in the other.

The illustrations here are examples of what a page of student studies should look like, and are best described as exercises in form. The same form which we see here applied to the human figure will be equally applicable later to whatever the subject matter happens to be. Involved here is the ability to translate into a different medium.

In the case of drapery, one becomes conscious of rhythm, and then that is found to apply no less to the figure itself. We start to go beyond surface aspects and into deeper, more penetrating observation. I point this up now because of the value which is too often placed on natural talent, whereas it is my belief that inspiration and perspiration are divided more into ratio of about one to three.

This is academic study in that the chief purpose is the gaining of an aptitude, divorced for the moment from eventual use. It is not easy and nobody will contend that it is. I have recently found, during a stint of criticizing in a life class, that the instructor's job is by its character easier than the student's, and for this reason. The more discriminating eye sees immediately the discrepancies between the subject and the student's attempt to reproduce it. The oral criticism can be accompanied by the graphic one and together become one statement — a statement usually of criticism, which is infinitely easier than making the original. It is also limited in scope, whereas the student drawing had, or should have had, no such limitations.

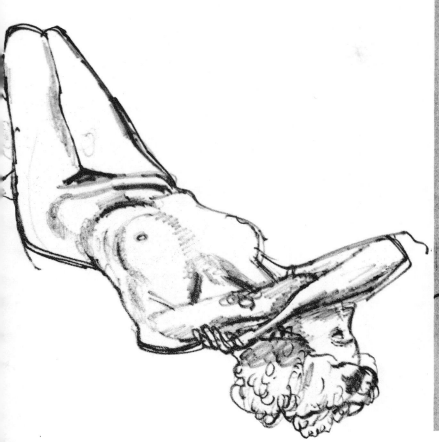

Sheet of Studies

This back view is a simply-modeled
study of a solid figure in graceful gesture
It is drawn with particular attention to
the silhouette and by constant compariso
of one edge against another, only with
a view to realizing the inner forms.
At this stage nothing should be drawn
which does not contribute to the
delineation of the form as it appears.

Studies in repetition

30

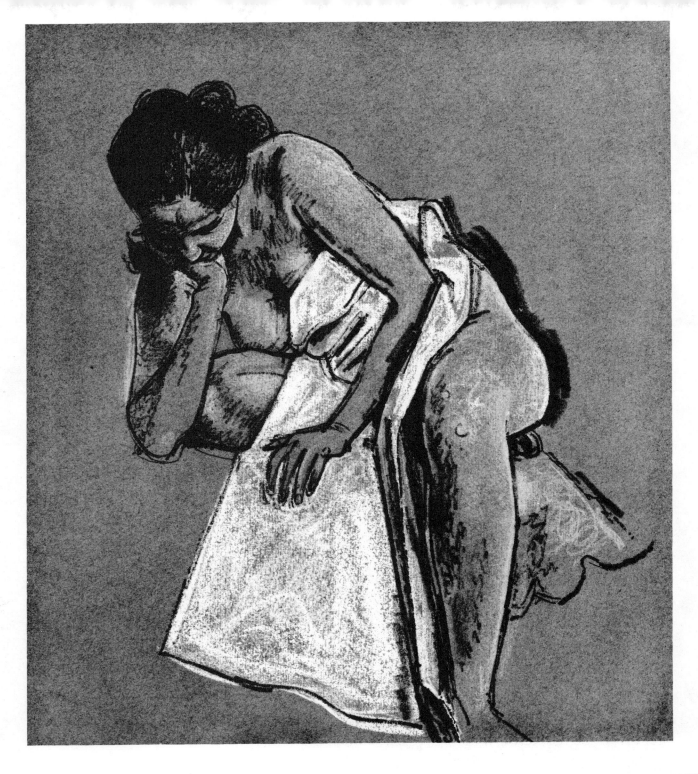

Many painters have used drawn studies to paint from. The practice is not too common today, except when a complicated design is impossible to improvise on the spot, such as a mural painting.

But it is still a good thing for the student to keep in mind while drawing, if only to prevent aimless observation.

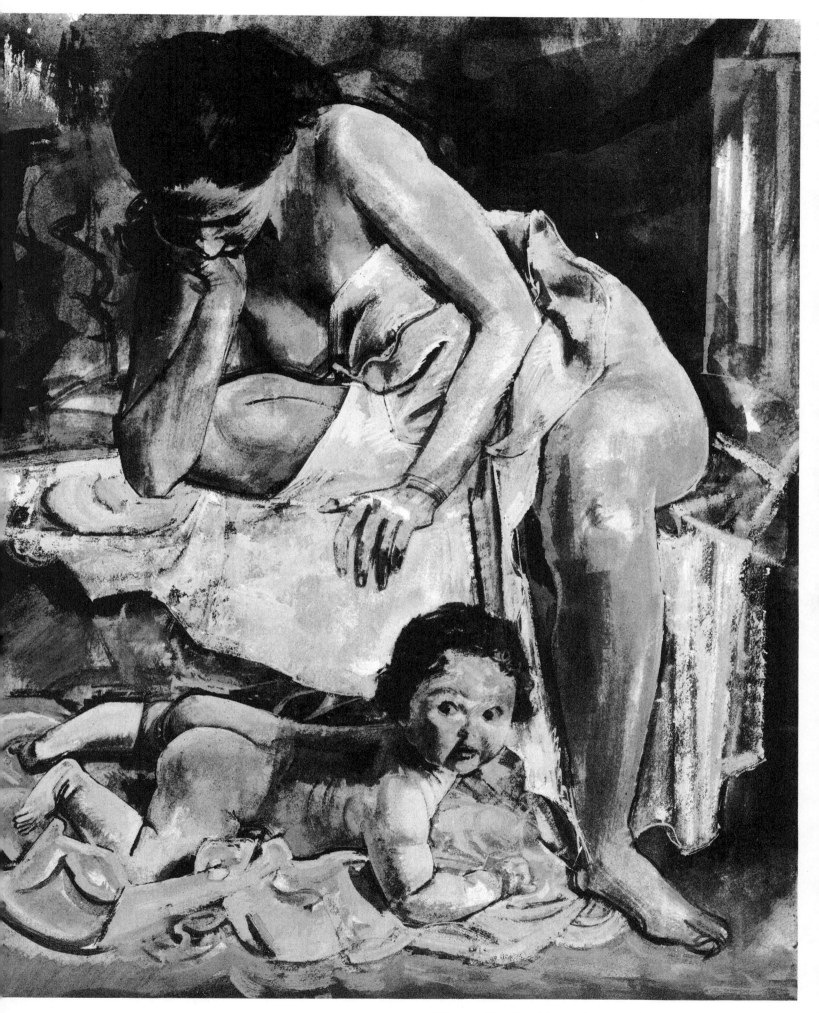

The studies should be a basis for improvization. It is possible, although it is not done here, to distort aesthetically

3. Questions and Answers

Years ago one graduated to the life class after a period of drawing from casts, but as this is no longer required, we will assume that the student is enrolled in the life class and is preparing to achieve competence in drawing from the figure. One might ask, "Why the human figure?"

It is rather hard to answer that question, beyond asserting it is customary to draw the figure — an unconvincing reply. One reason might be that since the human figure is not covered with fur, its form and construction are more observable than if we drew from fur-bearing animals. It would be presumptuous to say that the human figure is more beautiful than those of other and lower animals. Some are and some are not and, besides, we are not at this time concerned with formal standards of beauty.

Is it that we have to "learn the figure," that we will need it in our work?

This can hardly be a prime motive. The artist, especially the painter, is not concerned primarily with the undraped human figure, any more than he is with flora and fauna or any of the myriad objects which come daily before his eyes. It is even conceivable that "learning the figure" could be done from books or charts. The fact seems to be that there is really no reason for concentration on the figure except that the human model can be controlled to remain immobile or to move freely, and that being human ourselves we react sympathetically to that which is familiar.

That we go to life class to "memorize" what we see is also hardly credible. There are some who will later develop the ability to reproduce, without benefit of the model, a quite extraordinary approximation of the human figure. But in comparison with what the eye really sees when confronted with the actual subject, their result will not be impressive. It is hardly an accomplishment which contributes to fine draftsmanship, but is largely a trick which can soon become a formula. It is useless to deny that the ability to do this will develop, and sometimes to a high degree, for the memory cannot be stifled. The point we make is that we should not set out to gain this aptitude; it is not a prime consideration in the development of the draftsman. For as long as possible we should try to prevent ourselves from approaching drawing with anything but an open mind and a willingness to be surprised by what we see. If we are going to try to memorize the human figure, then we should consider memorizing the look of everything else in the world, also.

If we grant that draftsmanship seems to require the development of finely co-ordinated eye, brain, and hand, the eye to see with discernment, the brain to select and discriminate, and the hand obediently to record the distilled observation, then all this seems to imply a prime concern for accuracy. Why accuracy? The question is quite reasonable. Perhaps the best answer is: Why not accuracy?

The instrumentalist painstakingly learns to play scales with accuracy so that later he will be able to forget them. It is the rare music teacher who urges interpretation upon the pupil who cannot yet play the notes.

One virtue of accuracy is that it can be eventually discarded. The mature artist discards it when the achievement bores, conventional seeing no longer excites him and the discriminating eye rejects its restrictions.

Sir Joshua Reynolds said it better I think, when in 1782, in his eleventh discourse at the Royal Academy, he said of realism: "Why are we not always pleased with the most absolute possible resemblance of an imitation to its original object? Cases may exist in which such a resemblance may be even disagreeable. I shall only observe that the effect of figures in waxwork, though certainly a more exact representation than can be given by painting or sculpture, is sufficient proof that the pleasure we receive from imitation is not increased merely in proportion as it approaches to minute and detailed reality." Having thus disposed of realism, he concludes by saying, "We are pleased on the contrary by seeing ends accomplished by seemingly

inadequate means" which I believe is as true today as it was in the eighteenth century, although Sir Joshua and ourselves obviously have different ends in mind.

The need for accurate observation is pointed up in the experience of a friend of mine who found himself in Spain, speaking no Spanish, and with a sudden craving for a glass of milk. He resorted to the usual artist's procedure of drawing what he wanted, starting with what purported to be a cow. His memory of some details must have been sadly inaccurate, because the cooperative Spaniard left, and returned in a few minutes with two tickets to the local bull-fight!

But we must understand that failure to achieve realistic accuracy and conscious distortion are entirely different. Distortion is one of the legitimate means by which the artist conveys his aesthetic intention. Any convention the artist employs is in effect a distortion, whether of shape, color, pattern, or the conscious distortion of subject matter. But this is a conscious process and not to be confused with floundering in an unsuccessful effort to reproduce an image.

For the student then, let us say accuracy is a legitimate end. This is more than what is commonly called "photographic" accuracy. The camera sees little in comparison with the trained human eye and brain. Absolute accuracy is so impossible of attainment it is only a question of time when the point is reached at which the frustrated eye gives up and the brain and taste take over. But at that point we should have selection based on knowledge, unhampered by inadequate or faulty technical equipment.

If accuracy is our (perhaps temporary) goal then why should not anatomical knowledge be a help?

The question would never come up if we did not find ourselves confronted by the human figure, which for some reason we think of as "anatomical." The student is still concerned with the idea of putting down something that looks acceptable. His eye being as yet untrained, he searches for some aid. But it is better to discard at this stage the desire to *produce drawings.* It is far better that he concern himself with learning to see, so that with trained eye and hand he will be able to draw with understanding and conviction anything which comes within his range of vision, and which excites his interest — even if it have no more "anatomy" than a radish.

One great danger of knowing too much anatomy

is that it creates a tendency to rely on memory at the expense of observation. Confronted with a form which is puzzling, we will draw upon facts we know are common to all similar forms. A generalization takes the place of a particularization. Seeing then loses spontaneity and vitality. With a problem of extreme difficulty, such as, say the absolute foreshortening of an arm with fingers extended, we are forced to rely on the eye. No amount of anatomical facts will be of the slightest use except to produce a kind of diagrammatic approximation. This has little to do with the kind of draftsmanship we are concerned with here.

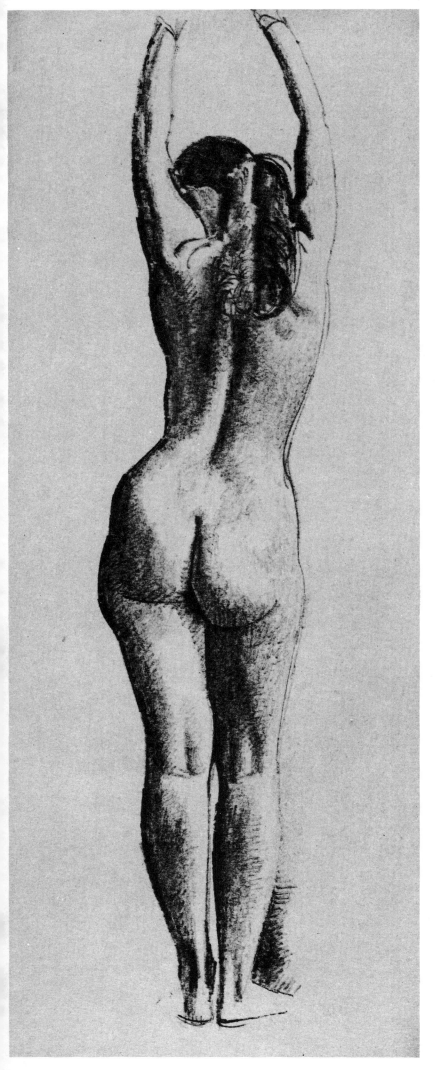

So let the student forget his desire to produce an acceptable drawing by resorting to a crutch and devote himself to breaking down those blocks which stand between what he sees and what he is able to record.

When distortions do creep in, as they will, it is a sign that one is moved by something seen, although the emphasis came unconsciously. One should not approach a subject like an automaton, determined to reproduce it mechanically, nor should one be paralyzed by fear at the enormity of the task. It takes courage to draw with conviction, courage of a particular kind, difficult to explain to those who have never tried it. It develops along with the confidence born of the trained eye and hand — that and the knowledge that if it doesn't quite come off, paper is cheap.

I spoke also of "the willingness to be surprised" as a contributory ingredient of drawings which excite our interest. This is most important, for no two things are or ever were alike, and it is the recognition of this which gives each its individuality and the drawing its character. In the human figure the study of anatomy will tend to inhibit and prevent this. One would not think of drawing a portrait anatomically, for here identification must be immediate. I like to think one can draw a torso or a limb with the same personal recognition. We are talking of course about "the general" versus "the particular."

First, however, come those things which *are* common to all form, such as bulk, weight, gesture, and rhythm, as revealed by the play of light.

The Sustained Study

This back view is a simply-modeled study of a solid figure in graceful gesture. It is drawn with particular attention to the silhouette and by constant comparison of one edge against another, only with a view to realizing the inner forms. At this stage nothing should be drawn which does not contribute to the delineation of the form as it appears.

36

The study of a semidraped figure is made more interesting by the inclusion of a complicated pattern of the material. This latter should not be suggested casually, nor an attempt made to copy it mechanically. Instead it should be seized upon and drawn as an integral part of the whole design, which a study such as this is.

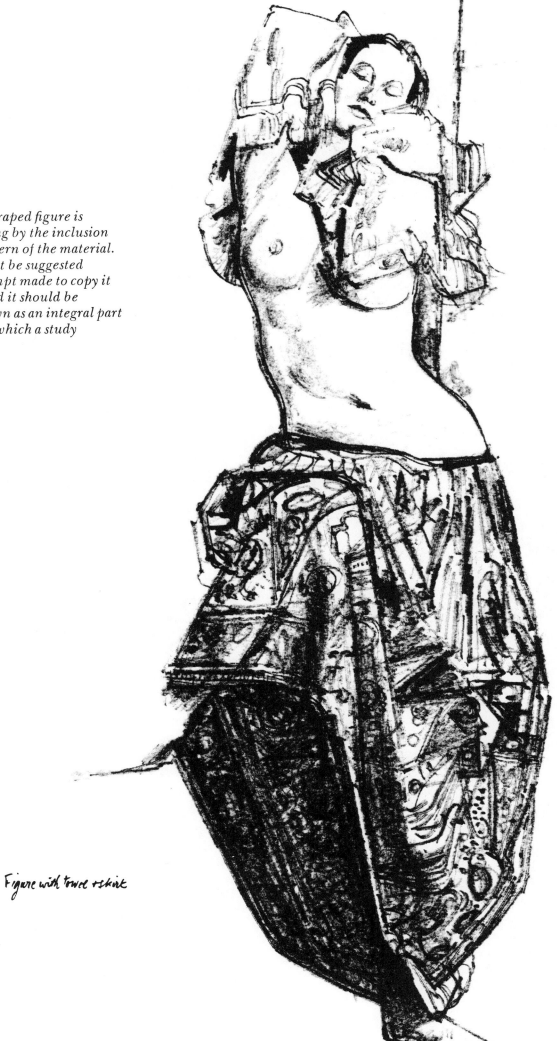

Figure with towel & skirt

37

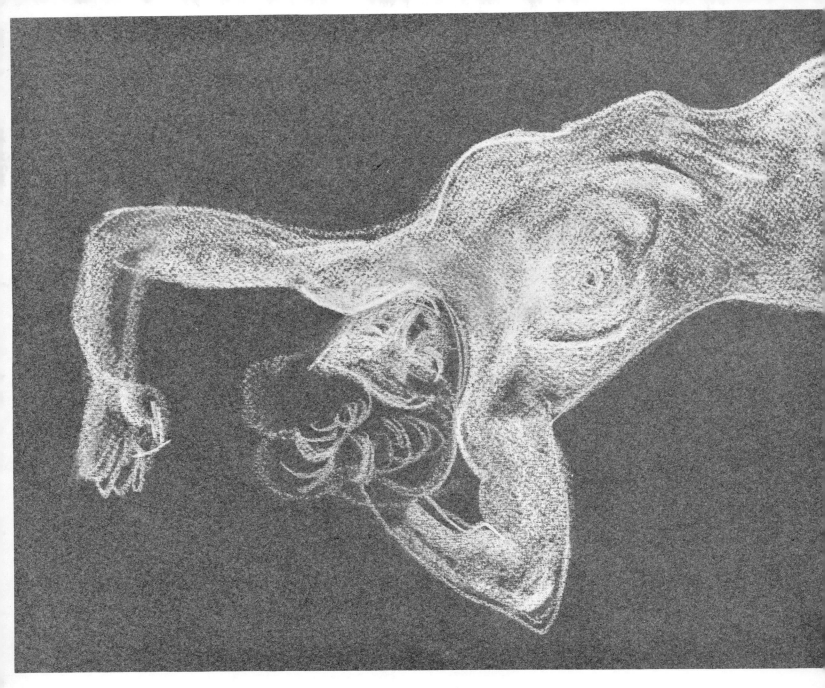

A way to avoid becoming mannered is to occasionally reverse the medium, drawing boldly in white on dark paper. This is preferable to simply adding white high lights to a study drawn in black, which is too often prettification.

Drawing the figure is a practice which has gone on for some hundreds of years and has now become a convention which we accept. However, it is doubtful if the reasons now are as valid as they were in the past, when many artists' paintings were peopled with nymphs and satyrs, when ancient classic myths formed the subject matter of others, and when nudes seemed to personify the essence of beauty in art. In those days it might be said that the student in the life class was training himself in an aptitude which was going to project into his career

in a most direct way, something which can hardly be said now.

But we still draw from the figure. I believe it to be a fine and valuable training, although I do not always go along with those who say one draws the clothed figure better with the knowledge of what is underneath, unless one is thinking of a tight bathing suit as clothing. I have drawn many trousered legs and I have yet to find the thought of the untrousered leg underneath much help — in fact I never think of it. In a fairly long career I have had to draw

women hundreds of times and for the most part I am impressed with the success with which the clothing designers manage to conceal what I can only suspect must be the female figure underneath.

We draw the human figure because we must have something upon which to base our training. It is a complicated mechanism and since we are not likely to exhaust its complexities it will probably be the customary training subject for a long time to come. It may well be that those who will paint semiabstract pictures involving wine bottles, grapes and guitar forms, will do so the better for having sweated over figure studies, for from among the most extreme abstractions it is not difficult to pick those artists who are able to draw, although within the picture there may be no single object capable of being identified.

Although I believe one should try to draw accurately, I do not believe that fine draftsmanship is synonymous with exact accuracy. It is usually based on "the thing observed," which, distilled by the personality recording it, may become quite distorted from the original. The test, if we can presume to put a yard rule to something so ephemeral as drawing, is whether it gives the impression of reality over and above superficial resemblance, and whether the drawing provides an emotional stimulus quite apart from its own subject matter.

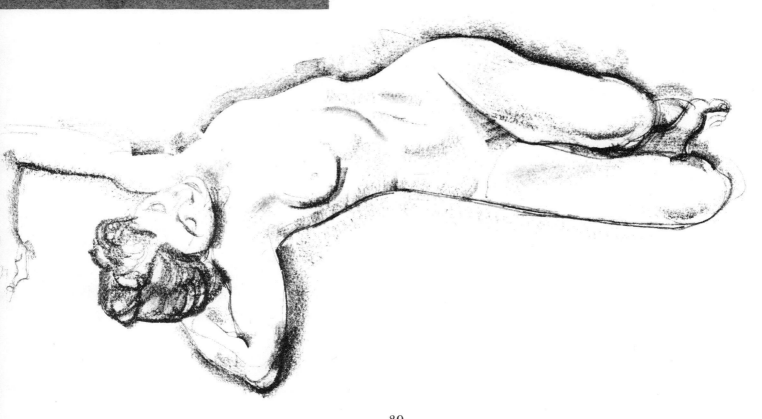

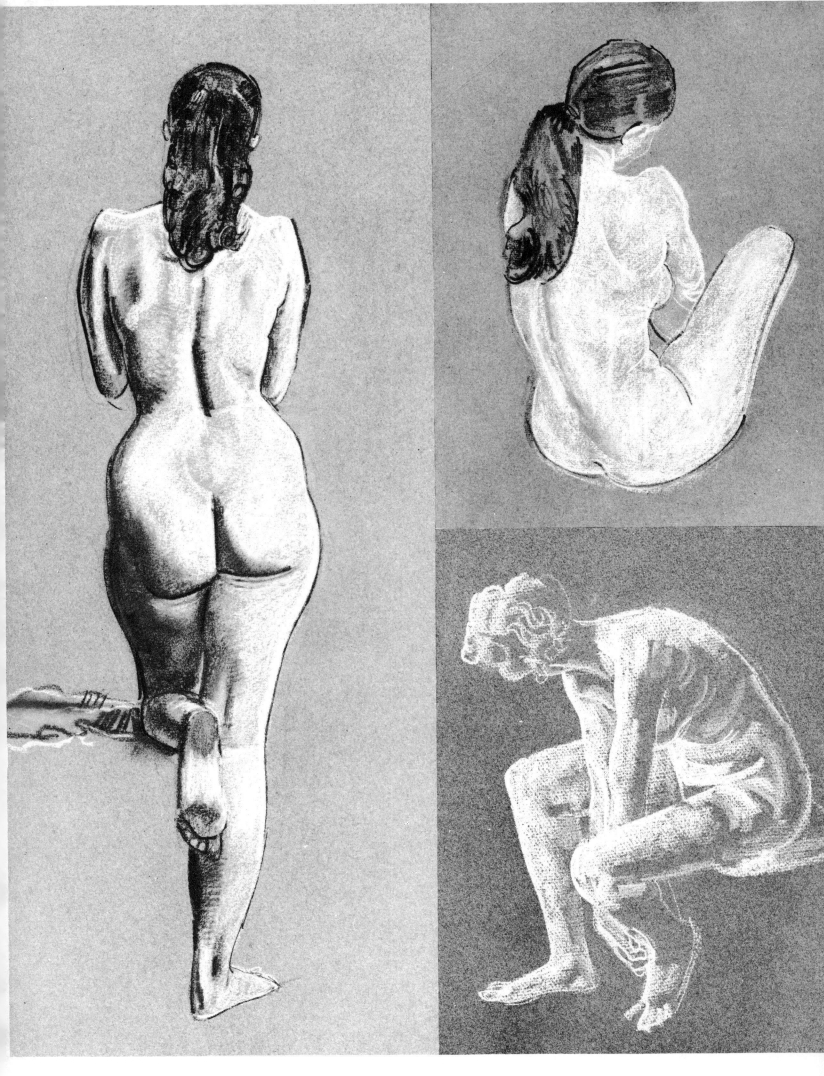

40

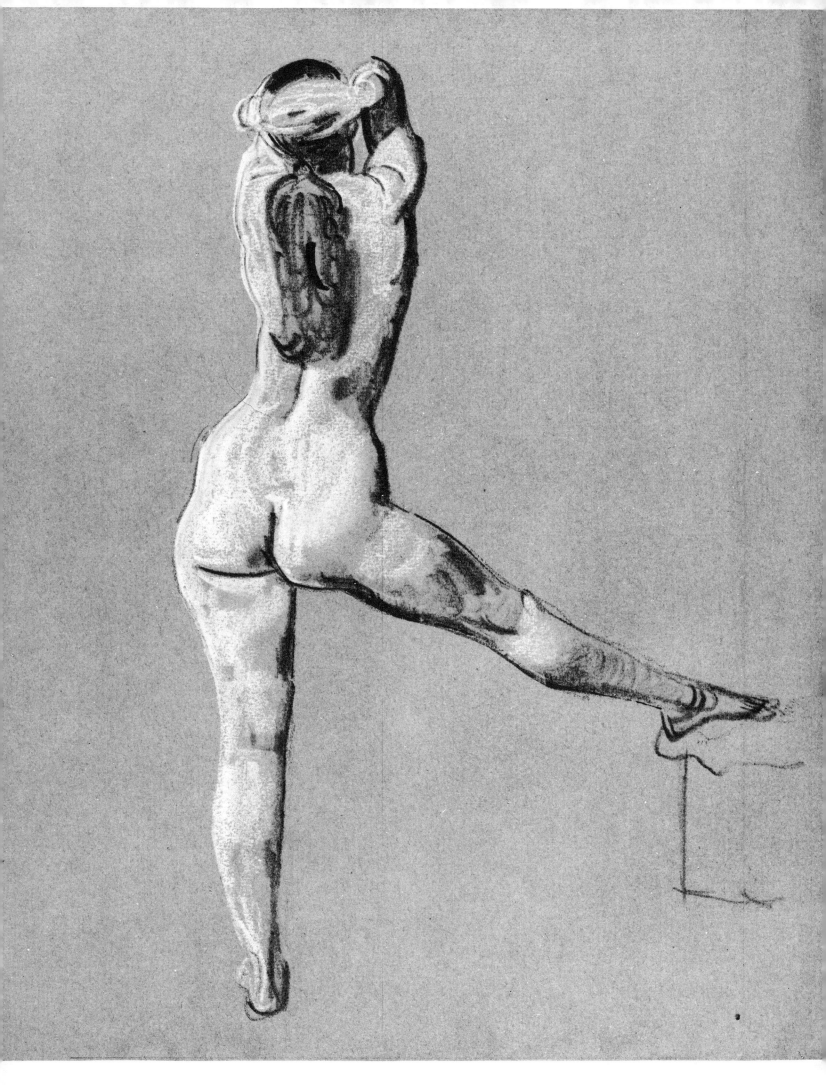

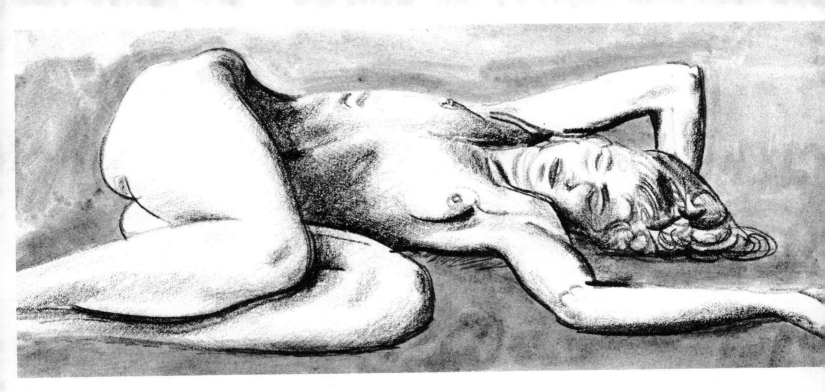

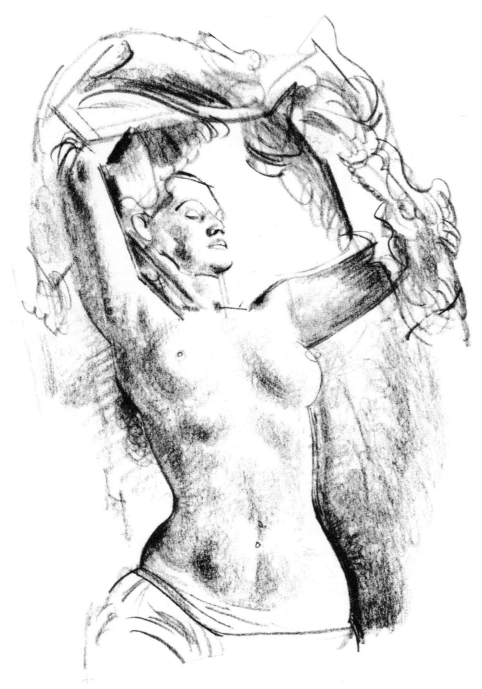

As the eye becomes sensitive and more keen, poses cease to vary in difficulty as they did at the beginning. They may seem more complicated, but even this is not really so. A simple immobile standing figure is probably as difficult as any to draw.

The drawing of a simple seated figure is
given character by emphasizing, and probably
exaggerating, the strange angularity
which was present.

43

Although the male figure obviously differs radically from the female figure, the actual drawing of it should not. It is here that one might think that a knowledge of anatomy would be a help, but close observation of the subject should reveal all the facts needed to draw from. We should also start designing the drawing as early as possible, its position on the sheet carefully considered. Also, as in this study of two figures, the relationship of one to the other, and the relationship of both to an imaginary frame — in this case the page size.

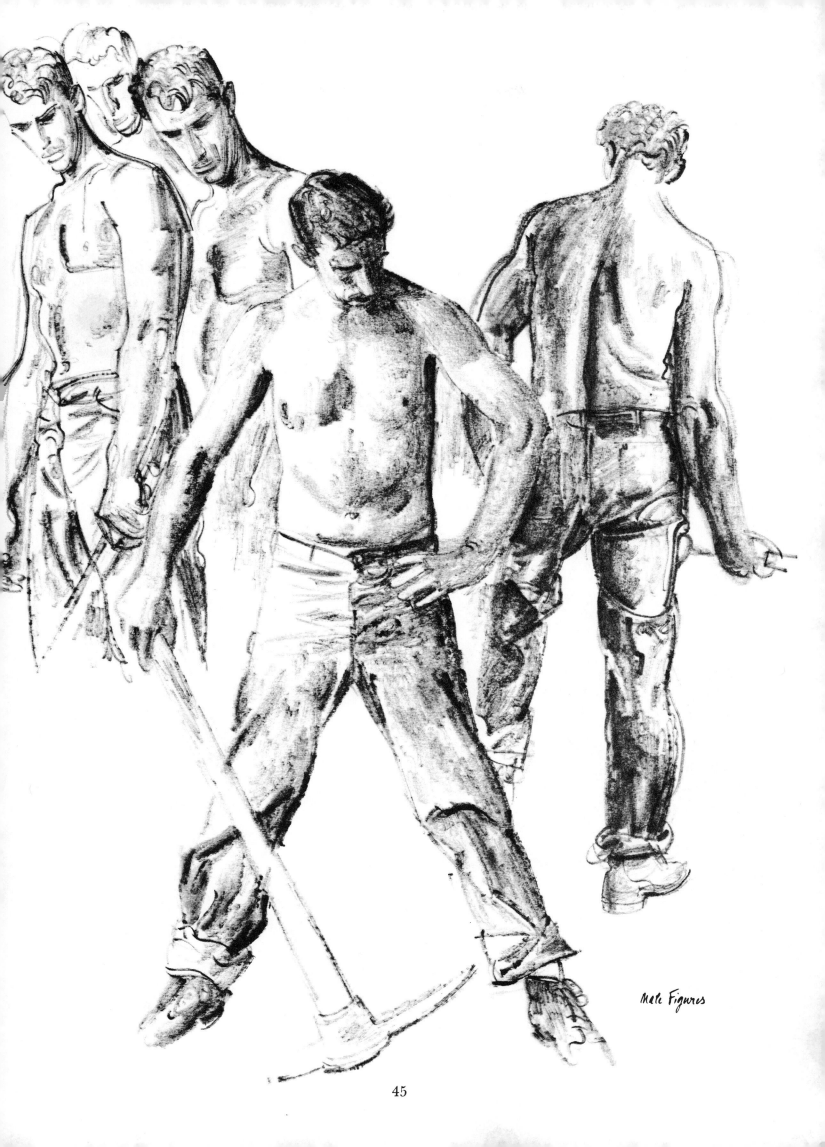

Male Figures

45

4. *Drawing Naturally*

The average life class is overcrowded, students in front straining upwards for an enlarged worm's-eye view of the model, those in back trying vainly to distinguish subtleties of form at a distance of thirty feet, the rest jogging elbows and being generally uncomfortable. In the rear a few hardy painters plant easels and engage in reproducing an approximation of the distant model which is largely if not wholly imaginary. Not that I wish at this time to discount the quality of imagination, but at this moment we are concerned with seeing, and recording what we see.

Daily or twice weekly the instructor moves from place to place, making a suggestion here, correcting a proportion there, only to have the same errors recur with monotonous regularity. The student believes that practice makes perfect, and that a period of manual activity will eventually produce a degree of competence. An atmosphere of funereal solemnity usually pervades the room, which the periodic rests do little to dispel. In short, the average life class is as uninspiring a setting for what can be the most exciting of experiences as it is possible to conceive.

Sometimes a visitor is puzzled by a strange ritual involving closing one eye, extending the arm toward the model with thumb bent onto the pencil and moving up and down until a measurement is recorded which is then compared with a measurement elsewhere on the model. Nobody has ever explained exactly what this is designed to achieve, but some students continue the practice as if performing a mystic rite. A question elicits the response that this is an aid to "getting the

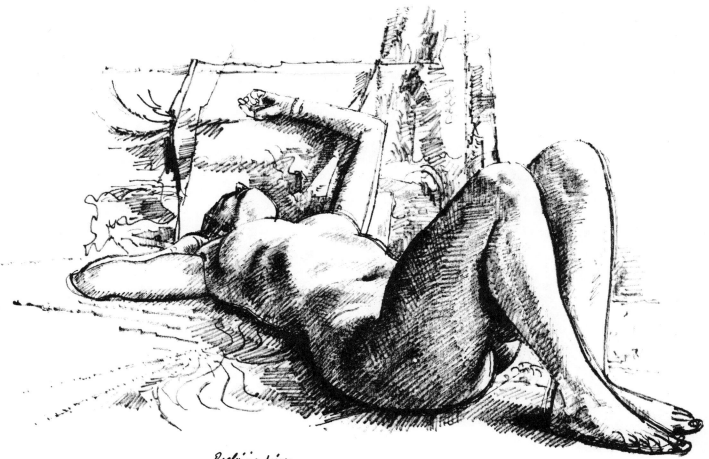

Reclining figure

46

proportions," but one glance at the drawing often shows that this laudable aim has not been achieved.

Here we arrive at the crux of the whole problem of inaccuracy, a point at which the student can be left to flounder for months, sometimes years. The logic of seeing must be brought into play. The student can forget about the measuring thumb and embark on a course which will broaden his horizon immeasurably and lessen the tedium and heartbreak of repeated mistakes. This is simply training the eye to see and the hand to draw *the size you see it,* which is drawing naturally.

It is a common fallacy that large drawings are somehow more meaningful than smaller ones, that small drawings fall into the category of sketching, while larger ones may be classed as serious studies. Why? Size has nothing to do with learning to draw.

What happens is that the student acquires paper which is more or less standard in size and is determined to use it to the full. He may find himself sitting up close to the subject or far away from it, but the determination to fill the paper persists. Tacking the paper onto the board in front of him, he often commences by putting down a few generally meaningless lines which indicate he is going to make an heroic study, or sometimes a miniature. This is done entirely without reference to the size he is seeing. But the *size one is seeing* should be the *only* consideration which should govern the size one draws.

If this sounds too technical and pedantic, the student can ignore it except as a statement of optical law. He is concerned with drawing smaller than life size. The only decision seems to be how much smaller. This should be decided naturally by his position in relation to the model and the position of his eye in relation to the paper. He should draw the size he sees from the point at which he is working. It will come naturally or it can be learned and studied by unfocusing the eye in a way which I will describe and diagram.

Recording the image, then, need not necessarily be undertaken in the conventional way, by starting at the head and working down to the feet. This may still be the most convenient, but if the subject is clearly *seen at once* it is possible to embrace the whole, recording first those observations which seem of greater eloquence, then slowly adding, refining and achieving reality until the image has been transferred as completely as possible. This last is important; the student should strive to go far beyond the point where good taste dictates he should stop.

Economy of statement may be and is the desired end, but after a period of drawing to a high degree of finish, this economy will come of itself.

The human eye is only a mirror and, barring slight physiological differences, what one person sees is pretty much the same as what the next one sees. That is to say, the reflected image is the same. The field of vision in front of one converges down to that point which is the retina of the eye. Now the student's eye is focused to the distance of the paper in front of him. Consciously or not, each time he looks at his subject for an observation he is actually comparing what he has already recorded with the field of vision as it has narrowed and passed the paper distance. Unless he can *see what this size is* and proceed to record it as seen, unless, indeed he is governed by a predetermination to make the drawing a certain size, come what may, he is probably on the way to producing one of those inaccuracies called "out of proportion."

The reason is that the eye sees one size, and habit or arbitrary decision has decided to put it down another size. This involves a mental calculation which, although comparatively easy in the first few minutes will become inaccurate or inoperative later as optical fatigue sets in.

One of the commonest faults is the large head and shoulders reducing to small and inadequate legs and feet. One starts with the desire to fill the sheet of paper, and this desire requires the head to be, let us say for argument, one and three-eights times the size that the eye actually sees it. Now it is impossible for anyone over any length of time to enlarge accurately by exactly one and three-eighths every visual observation made before putting it down. What he has already drawn will of course be some guide, but the eye and the brain tire, and natural sight inevitably asserts itself. When he arrives at the lower legs and feet, which is usual student procedure, he is gaily and correctly drawing what he sees the size he sees it, but in complete disregard of his original size decision. Unfortunately, two separate procedures have been employed and the one is out of proportion with the other.

Now this may sound elementary or it may sound complicated. Actually it is very simple and will repay a few moments of study. It has so great a bearing on the future development of the draftsman that the wonder is that it is not understood and universally practiced as student routine. The result of drawing natural sight-size is to rule out for all time the problem of inaccurate proportion.

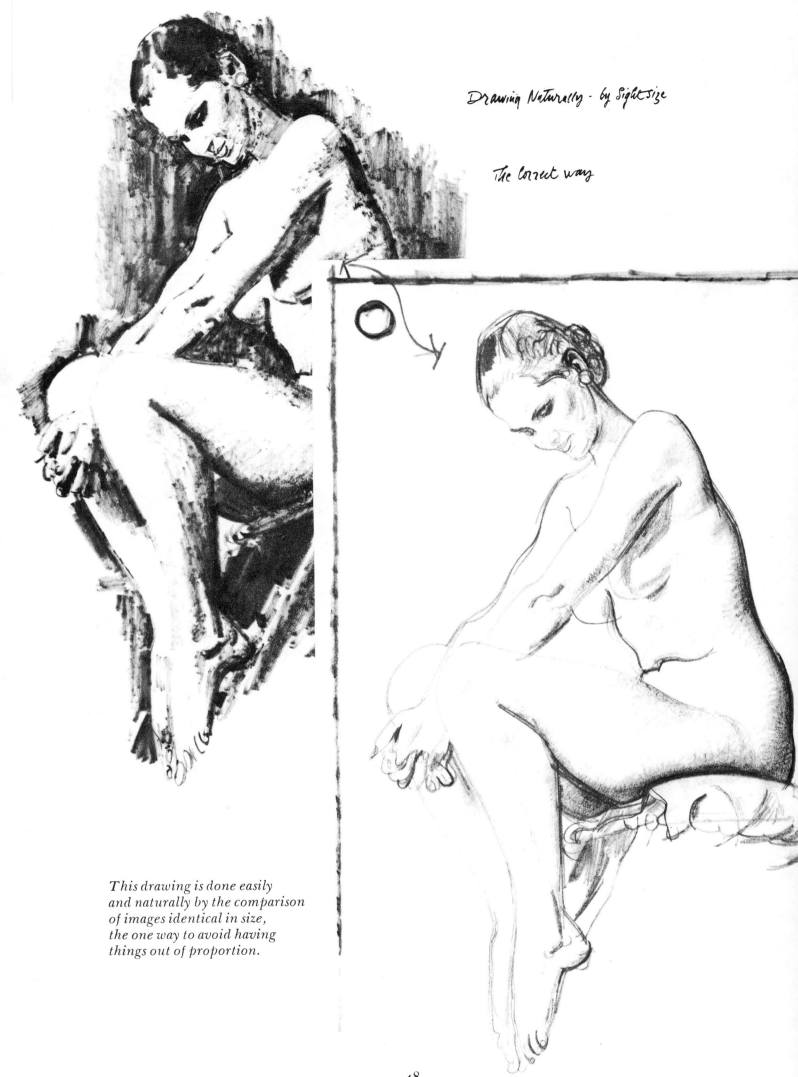

Drawing Naturally - by Sight size

The correct way

This drawing is done easily
and naturally by the comparison
of images identical in size,
the one way to avoid having
things out of proportion.

48

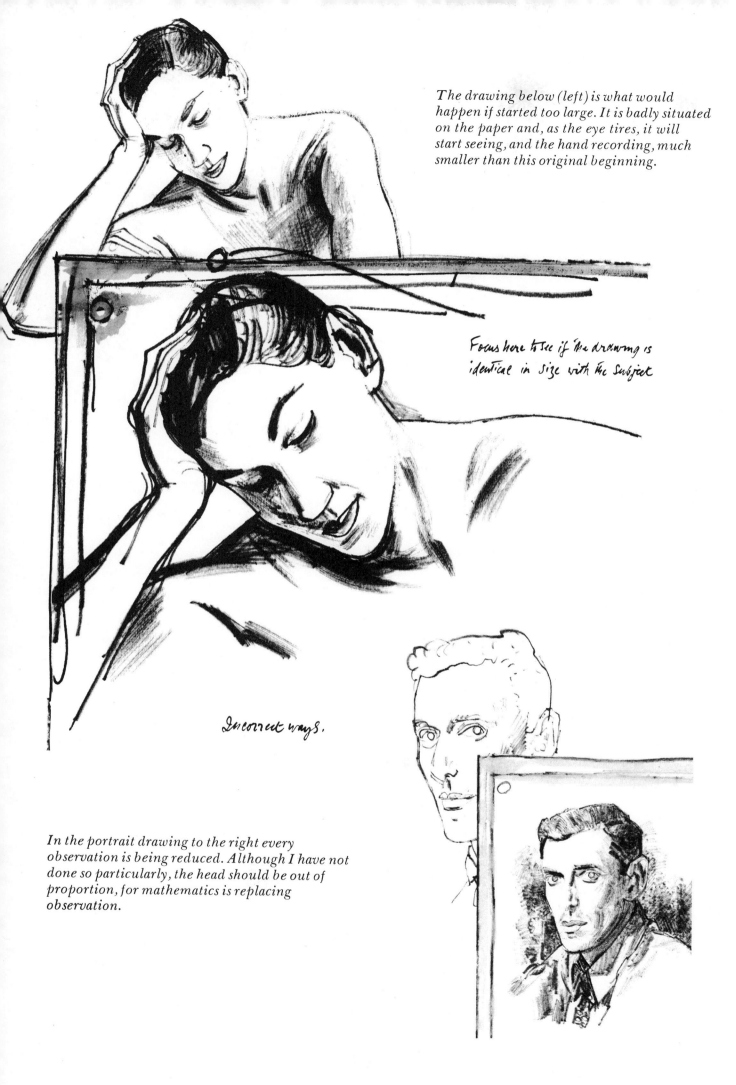

The drawing below (left) is what would happen if started too large. It is badly situated on the paper and, as the eye tires, it will start seeing, and the hand recording, much smaller than this original beginning.

Focus here to see if the drawing is identical in size with the subject

Incorrect ways.

In the portrait drawing to the right every observation is being reduced. Although I have not done so particularly, the head should be out of proportion, for mathematics is replacing observation.

Of course, proficiency does not come immediately. A lot of practice will be needed, but once mastered and followed, the student is freed from the bug-bear of "out of drawing" and from then on drawing for him becomes less a chore than an exciting pleasure.

Let us remind ourselves that although natural drawing obeys the simplest of optical laws, it is not an end in itself. The application of these simple rules however can produce the interesting draftsman with a great saving of time.

To determine the size one sees is quite simple. Arrange the paper as close to the image as possible and unfocus the eye until the paper surface and subject are both seen at the same time. The eye is used here as a "camera lucida," that mechanical apparatus with which a commercial draftsman can see his hand and the reflection of that which he is copying at the same time. In free drawing the image is not actually reflected, but with practice it is possible to train the eye to almost *see* the second vision on the paper.

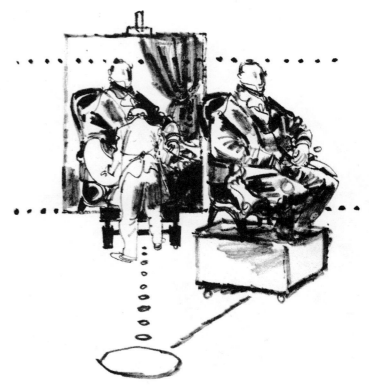

Without changing the positions of paper or model move the head back and forth and notice how the sight-size changes. As the eye moves nearer to the paper the comparative images become smaller and they increase in size as the eye moves away. This makes clear the necessity of trying to anchor the head while drawing and of not making observations first from one position, then from another.

If one wished to draw life-size from the model by this method the paper or canvas should be placed directly alongside the model. Then from any observation point the eye sees images identical in size, although a mark should be made on the floor and the student must return to it for each observation. It is even possible to paint or draw from life, *larger* than life-size, still by the comparison of identical images. The necessity of ever wanting to do this is remote, but it could be done simply by placing the drawing surface this time *behind* the model plane, but continuing to make all observations from a predetermined point in front of both.

So much for drawing things as you see them. It may seem a bit pedantic to have to worry about how large you are drawing and whether or not it has any bearing on the quality of the study, but as I stated earlier, a good drawing is dependent on the perfect coordination of eye and hand, and that will be compromised if you have to take time out to think. You may have to think about what I have just described for the first few times, but it will soon become habit.

All drawing from a subject is an act of memory. At that moment when the artist is tracing his line on paper he is no longer observing. The image observed has become a mental one, and consequently the success or failure of the drawing will depend on the nature of this succession of mental images. The more vividly the subject lives in the mind, the more acutely its unique plastic and linear organization is remembered, the more particularized should be the resultant drawing. Again I say that this is more likely to occur if our vision is not complicated by the intrusion of mathematics, simply by drawing naturally.

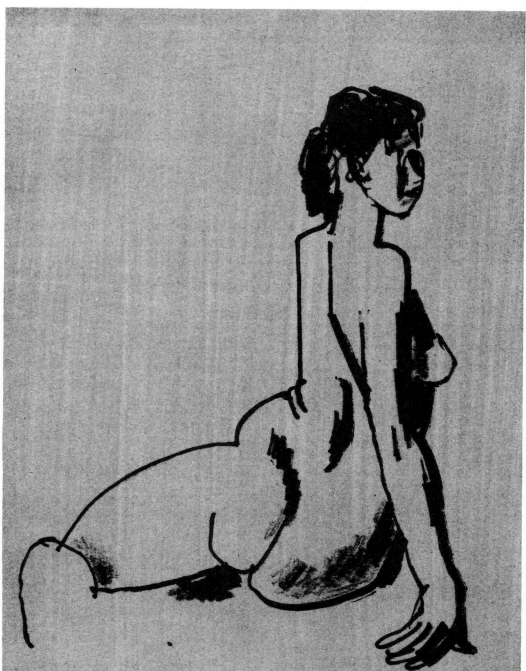

The Calisthenics of
Figure Drawing

On these next few pages are examples of
gesture drawings, fast, immediate impressions
of the model almost in movement.

Rapid gesture drawing

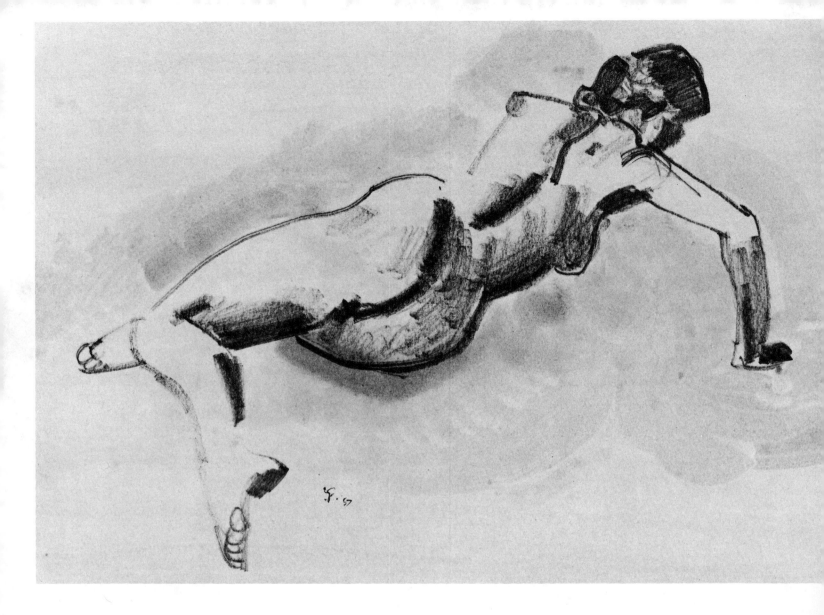

The model can be instructed to change pose at short periods without being told, and each new position should be drawn without pause — as continuous exercise. Some attempts will seem like meaningless scribbles, others may have an extraordinary vitality and spontaneity. But either way the exercise is an invaluable antidote to the long sustained studies.

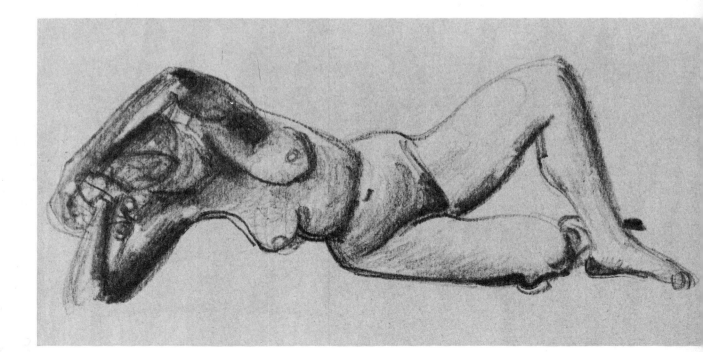

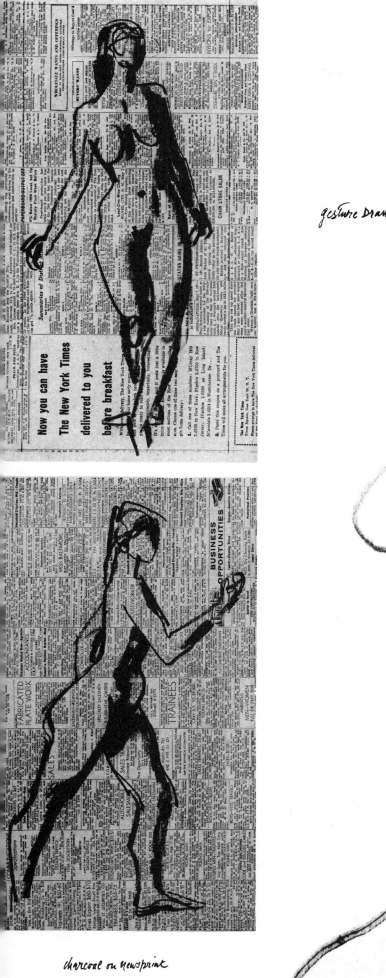

charcoal on newsprint

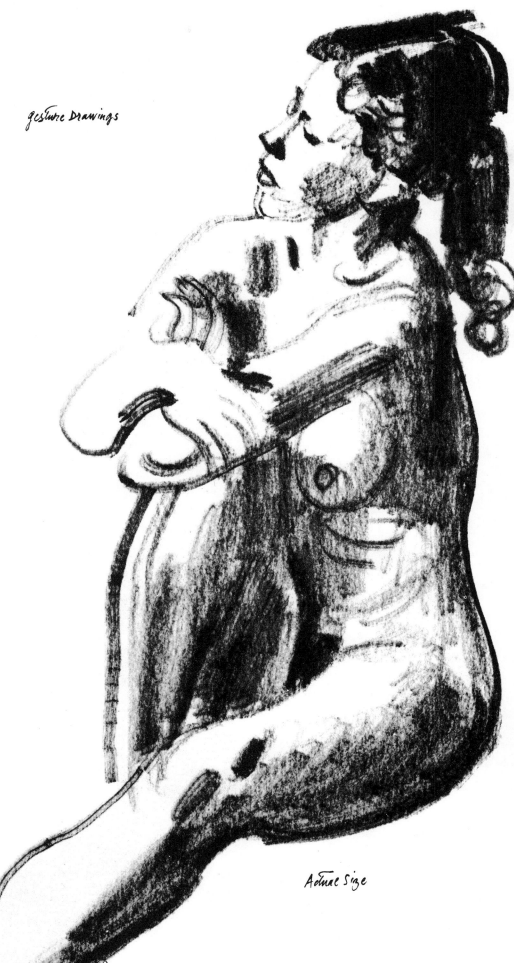

gesture Drawings

Actual Size

For the exercise of gesture drawing, use plenty of cheap paper. These are fleeting impressions, and the eye should be alert to only the essentials.

Some draw these without looking at the paper, simply allowing the hand to record visual impressions. Mine are not done that way, but attention should be glued to the subject and the hand allowed to obey automatically.

These took an average of three or four minutes each. Coming at the end of a day of more searching study, this exercise is guaranteed to send the student away exhausted — but stimulated.

54

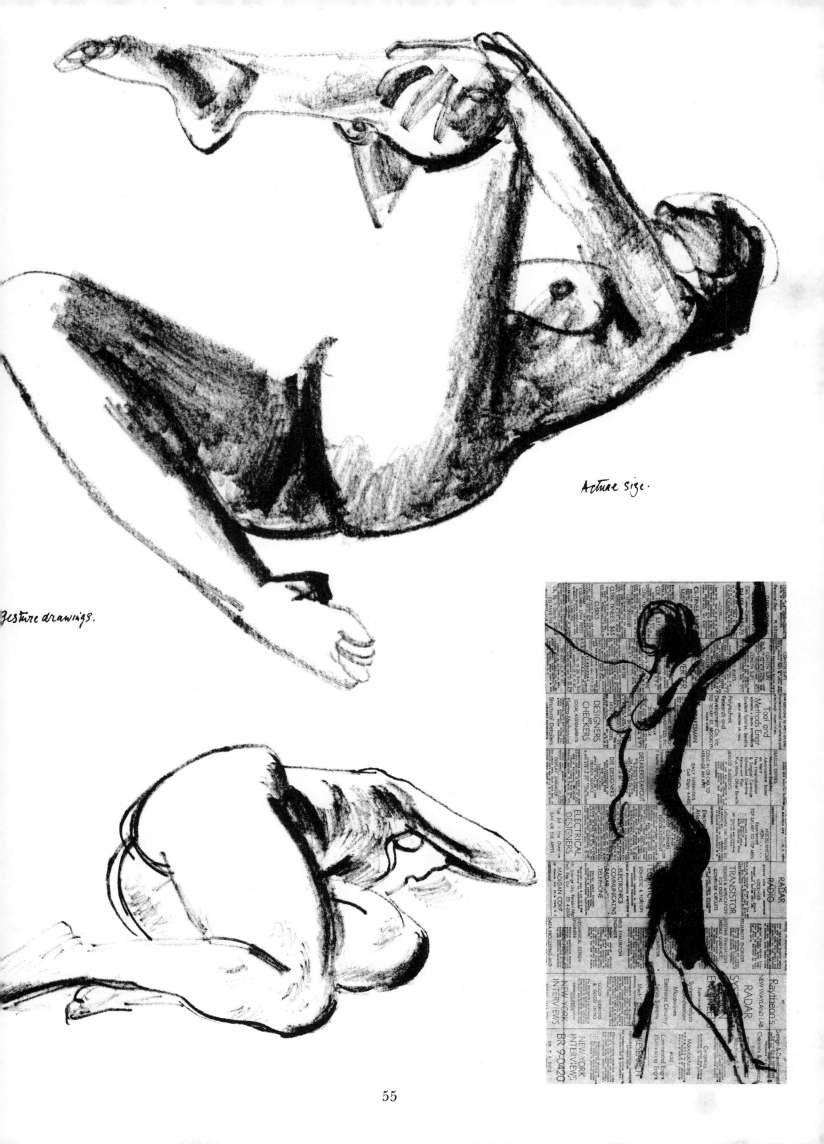

Actual size.

Gesture drawings.

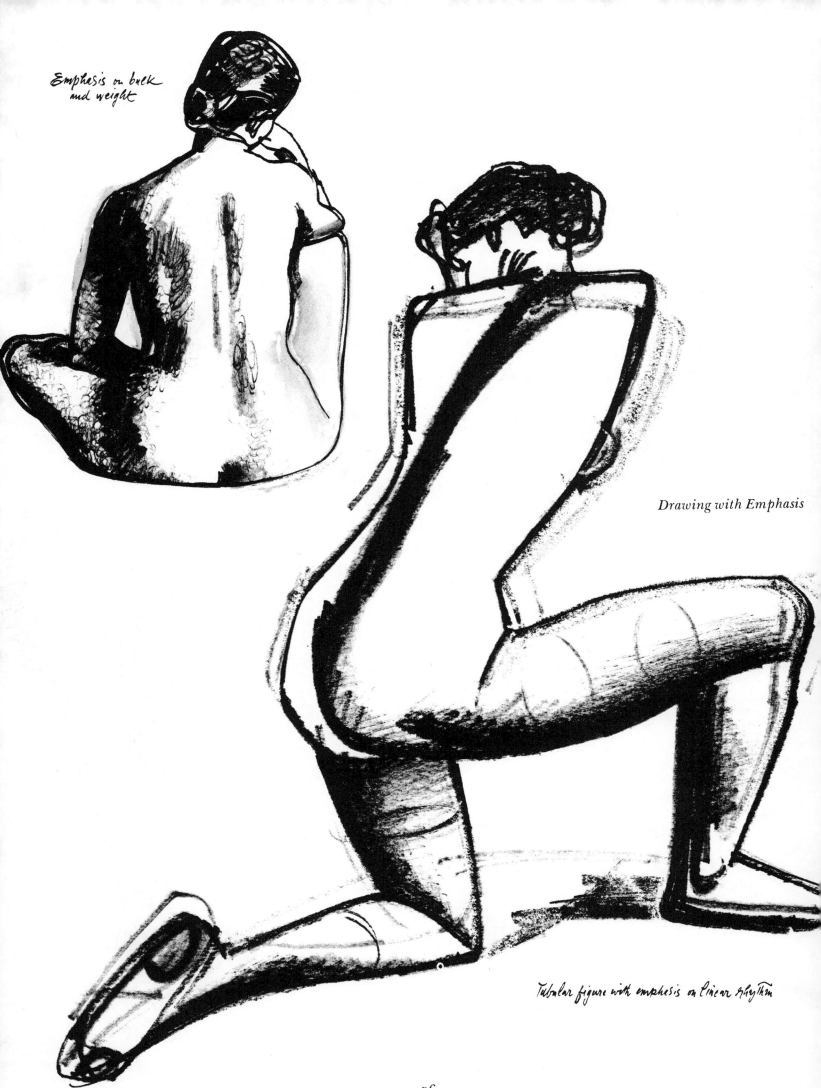

Emphasis on back and weight

Drawing with Emphasis

Tubular figure with emphasis on linear rhythm

Resting model, with emphasis on rhythmic angularity

There comes that moment of study when exactitude or imitation gives way to interpretation, when the student who up to now has been mostly copying begins to draw. The first manifestation of this is an increase in emphasis. Drawings which up to now have been little more than a sum of the separate parts begin to be conceived as a whole and with clarity which is far in excess of what is being reflected on the retina.

By obeying the impulse, the result is sometimes a departure from conventional reality, but it often evokes a sense of life and beauty all its own.

It should be allowed to come naturally, for to do this with conscious effort can result in a sterile distortion.

The four studies here seem to illustrate, if only in a minor degree, the substitution of something else for the obedient hand.

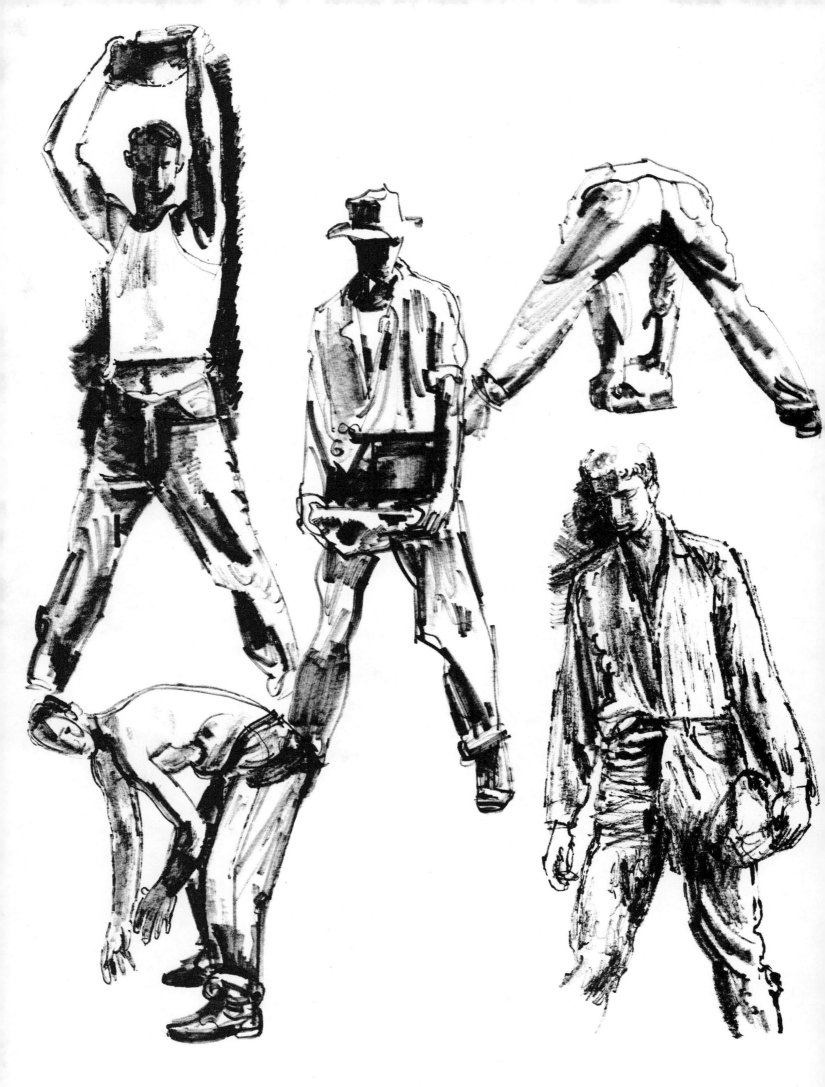

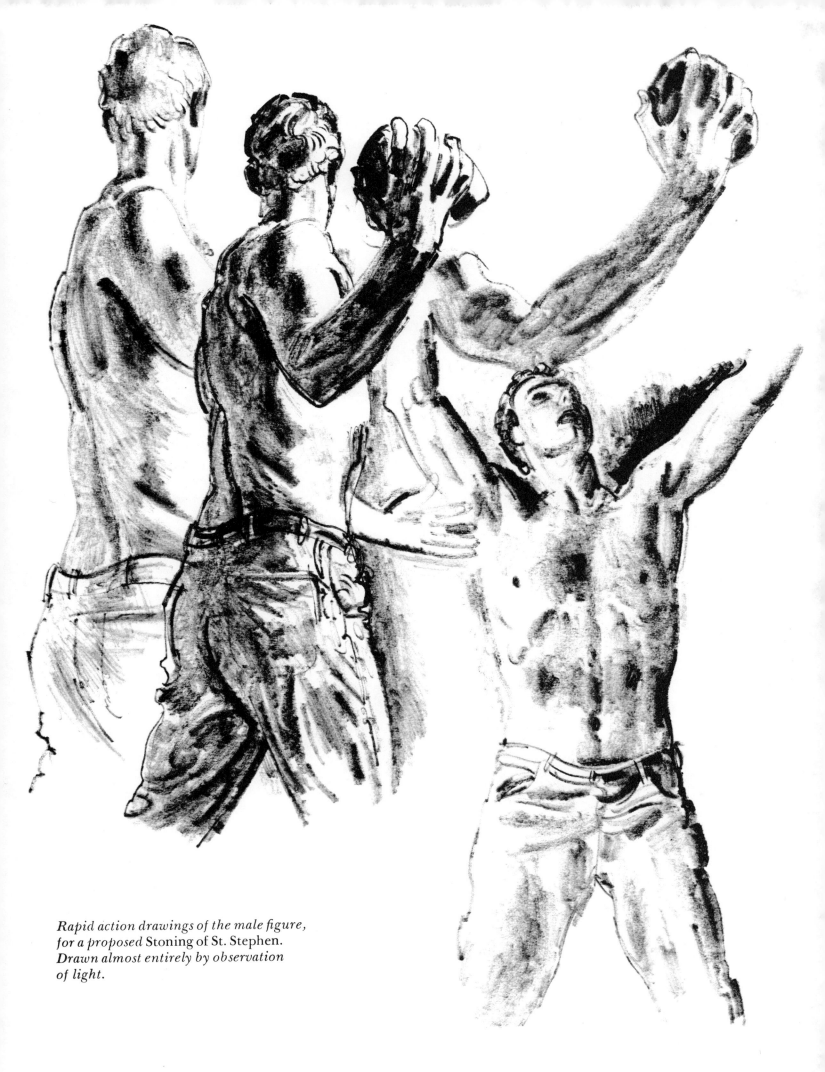

*Rapid action drawings of the male figure,
for a proposed* Stoning of St. Stephen.
*Drawn almost entirely by observation
of light.*

5. *On Technique*

No mention has been made of technique. The most important thing that can be said is that if the student can truly be diverted from conventional thinking he will soon find his own expression on paper — and it will be vital and original.

Technique is style, in its more superficial connotation. A style is rarely, if ever, acquired by conscious striving, or by concentrating on developing one. It comes naturally and unconsciously as the by-product of being absorbed in other more important things. It is the mechanical performance by which the artist expresses his conceptions. To believe that style can be copied, except very superficially, is to believe that the air of a well-dressed woman can be duplicated by putting the same clothing on a mannequin.

The final development of the student as an artist will not be adversely affected by adherence to a standard of strict accuracy at this time. One advantage of a concentrated period of this kind of drawing is that one is able to get through the phase of seeing conventionally, and arrive the quicker at a newer and more exciting kind of seeing and drawing. Another embarrassment one avoids is that which occurs when the artist in mid-career finds himself lacking in the basic aptitudes which should have been developed and forgotten years earlier. He never learned to draw what was visible.

I suppose true technical information is that found in books such as those which describe pigments, and give information about materials which experience and science have found to be helpful.

But too often "technique" is used as a synonym for a manner of working. Since that should always be dictated by other and special considerations, to isolate it for special comments puts the cart before the horse.

In showing a few examples of drawings which differ superficially in appearance, I would make it clear that the decision to use one medium over another was arbitrary, and usually determined by what was closest to hand and what the problem of drawing seemed to be at the time. Once the decision to draw in chalk, pencil, or pen is made there are peculiar qualities in each medium which dictate

its use if we are to avoid forcing it, and that I suppose can be called a technique.

But since throughout this discussion I will urge that nothing be allowed to stand between seeing — and by that I include inner seeing — and the completest realization of it on paper, any further discussion of technique would only be a contradiction.

Childs head

Lord Russell

The heads on these pages do not constitute a category as such, but more a demonstration of the use of materials to different ends. In some cases one can make a deliberate choice of medium, in these cases it was the only one at hand. These are techniques only in that the means accommodate the ends. I dislike the word technique as applied to drawing so much, that it is with difficulty that I can find much to say about it. For me it should not exist in the popular sense. That one has more technical facility than another I will admit, but when it shows it is dangerous.

When something appears on a TV screen which seems worth recording, we naturally choose the simplest means to do it. It is a constantly moving subject, transient and elusive, and more of a challenge than an aesthetic motive. I used a blunt felt pen for this.

The drawing of a child was the result of being handed a stub of pencil with the request to "please draw me too," and we complied.

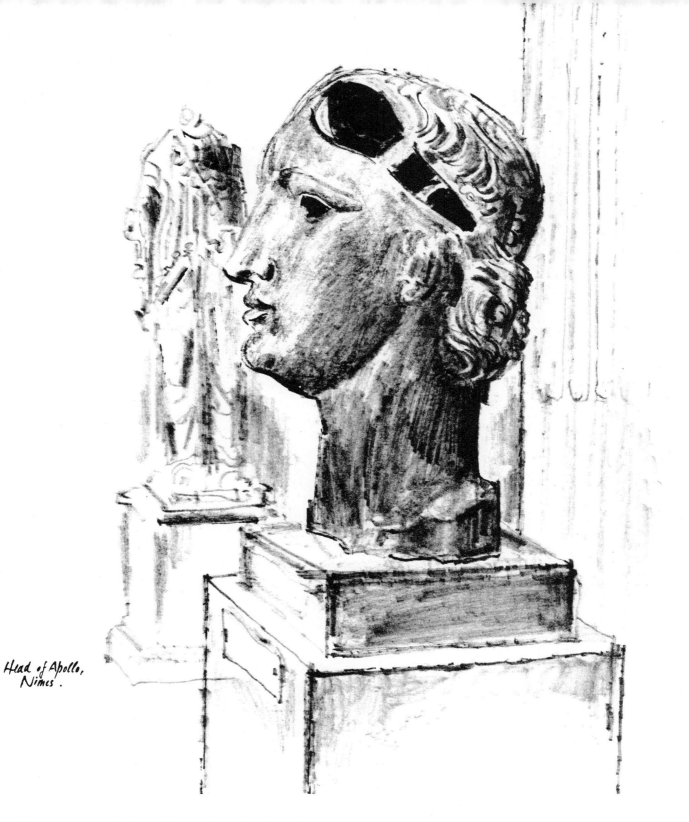

Head of Apollo,
Nîmes.

The bronze head of Apollo, on the other hand, was
seen during a visit to a museum. Its strength and
beauty haunted me after leaving, and weeks later I
drove miles off a route to see it again — and this
time made a drawing of it. I might have bought a
post card of it at the door, but this way I think I
know it better. Inadequate though the drawing is in
comparison with the subject, it was a personal
experience.

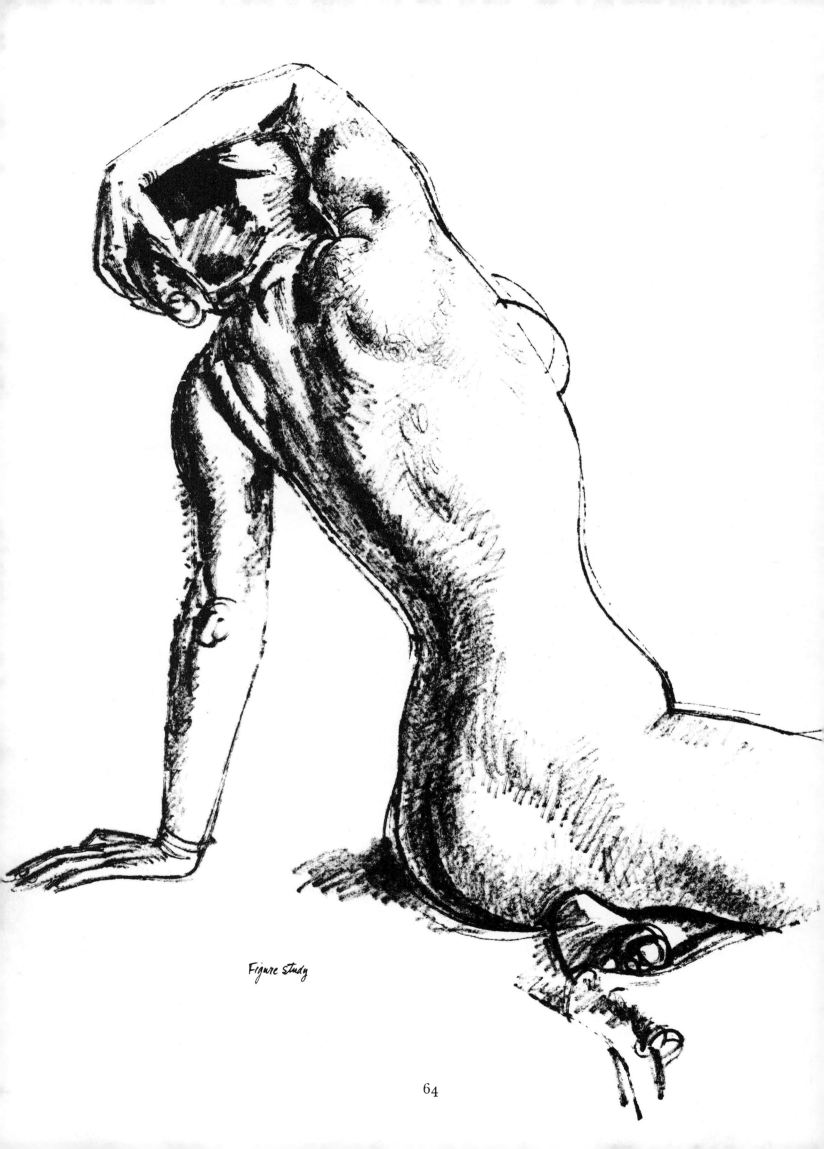

Figure study

64

6. *Variety of Drawing*

One should never avoid something which looks difficult or seek to solve a drawing problem with a convention. This may momentarily fool the unknowing, but never oneself. We are embarked upon a course of self-development by discipline. We defeat the end by stooping to any self-indulgence at this time. Often the eye will not know what it is seeing, although the image is being registered on the retina, but in time this knowledge will come.

Remember what was described as the objective of many of the old masters in their studies — which was to take from the model the maximum of information for future use. They were, in drawing, often not out to produce works of art — they were recording facts or experimenting in an informal way with a problem. Their observations had one advantage over that of the student in school in that they were *aware of the facts they would need.* Observation was thereby given a reason and an impetus; the drawing consequently gained in clarity and force. It is easy to think of a similar compulsion for oneself today — if it be only the desire that tomorrow, or some day hence, the drawing will continue to demonstrate that it means something. It should be a document, a clear record of what was happening on the occasion.

Now would be the time to study avidly the drawings of Dürer, Michelangelo, Rubens, Watteau, all the great draftsmen of the past up to the present time. These studies have more than an academic interest to us today. They show us what drawing can do.

It will be noticed that throughout this volume we stress three-dimensional drawing. This is the representation of length, breadth, and depth on a surface which has length and breadth only.

Since the absence of light is darkness, only by the presence of light do we perceive form. Therefore, if we draw the light we record the form.

But some may still have a preference for a different kind of drawing. One hears the phrase "I like simple line drawings." No wonder, for a line drawing subscribes perfectly to Reynolds' dictum of our pleasure in seeing ends accomplished by seemingly inadequate means. The attempt to enclose space by a simple line is one of the earliest and most primitive ways of developing the powers of observation, of registering in permanent form

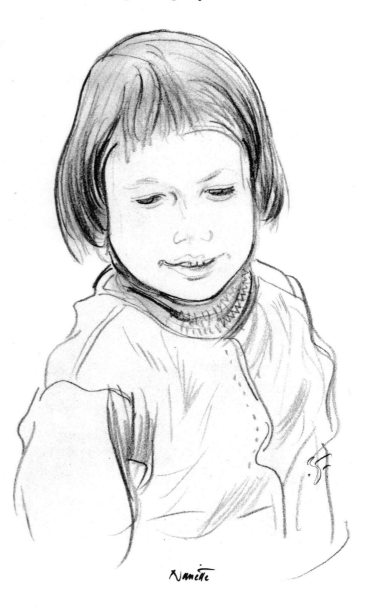

Nanette

facts needed to reason from, and to convey to others the shapes of things observed.

The line convention was probably brought to its fullest fruition in the decorations on Greek pottery, but here it went beyond the simple recording of the silhouette. The line pattern of the Greek artists conveyed rhythm, form and movement to an extraordinary degree, and became a final and complete pictorial art form. In fact it is called vase "painting."

Three-dimensional drawing will sometimes employ the simple outline, but the shape enclosed is of more importance than the means taken to enclose it. If we believe this we will employ any means to realize the form — to supply that third dimension which is absent on the flat surface before us.

In nature of course there are no outlines. The outline is a human convention. It dates back to primitive times, but is still a convention. But for us the most fruitful principle is that in registering form, we choose a way that is inherent in the subject matter itself. Occasionally one is presented with a subject which can be conveyed almost completely by a simple outline of its silhouette. At other times this is not so and the attempt to force such a result will produce a mannered, self-conscious simplification for the sake of an obvious and sterile decorative end.

The less we think about the means and the more we concentrate on the object itself, the more likely we are to be drawing with meaning almost before we know it.

There are ways of drawing determined by reproduction, but these I think are better described as techniques. In pure free drawing the same artist may draw in a variety of manner, although on examination the differences are less real than seems apparent at first.

One draws differently with a piece of charcoal in hand than one would with a pen, and still differently with a pencil or silver point. But if we analyze it we see that what actually happens is that one is forced to submit to the limitations of one medium and to take advantage of the opportunities of another. There are media with which one can almost paint — but it would be difficult (although not impossible) to do so with a pen and black ink.

Then there is the limitation of time to consider. Faced with a situation which we know will be momentary, and without the ideal medium to hand, excitement and urgency dictate a kind of shorthand which conveys to the observer later a similar excitement. Unlimited time and choice of materials is not always an advantage, for some of the most vital drawings have been made under far from ideal conditions.

One other operative condition might be necessity. If the artist is making studies for a picture or a mural which is predominantly flat in pattern it is not likely that he would do more than extract the qualities he needs from the model — or at least give pattern the greatest emphasis. The same artist tomorrow might draw a portrait head with an eye solely for character, and model completely all the delicate tonal nuances necessary to realize fully his subject on paper.

Finally there is that almost indefinable decision born of the affinity between the means and the subject. I cannot imagine, if the choice were mine to make, starting a drawing of a young child with a crude heavy chalk, yet I might find this eminently fitting for the head of a prize-fighter or of a man working in a field. One look at the delicate modeling of the child's features and we automatically reach for the pencil, which we know will record them with the greatest sympathy. These are the unconscious decisions, but we make them whether we know it or not. Although the results could make the title above, Variety in Drawing, seem valid, actually I don't think they do. We are the same person, drawing in different media, under differing conditions and for specific needs, and therefore the variety is more apparent than real.

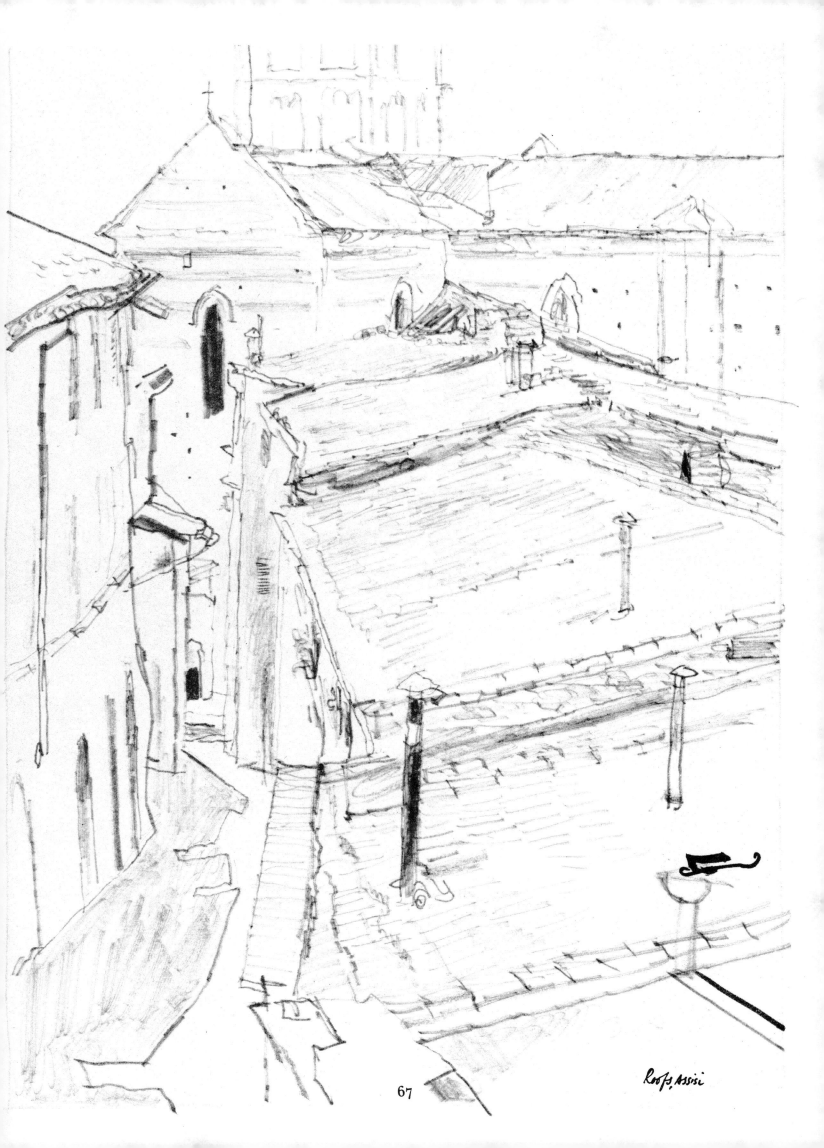

Roofs, Assisi

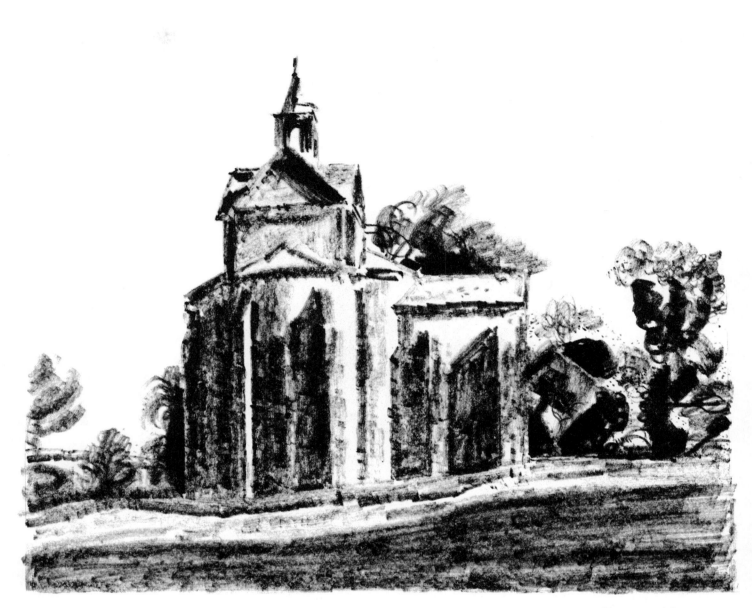

Chapel near Arles

Variety in subject matter is, of course, another thing. Up to now we have spoken of variety in a different way, more as the adapting of the means to the end. I have warned that the subject matter of the drawings which illustrate this text would be purposely varied as an example to those who think of drawing as a subject capable of being categorized. Pigeonholing may be useful for the purposes of the librarian, but the work of the best artists of the past and present resists it.

I have been asked whether drawings like that of the small chapel in evening sun "actually was drawing?" I confess I don't know whether or not it actually was, or is, but since it was done with a moderately dry medium, and in one color, I suppose it would qualify. That is the trouble with trying to classify things — one often has to give one's self silly answers. Is it the dry medium which makes it drawing? Because, if so, it brings to mind the many paintings one has seen, in full juicy palette, but which never got beyond the point of simple delineation, and could have as easily been done with a pencil or chalk, despite the presence of color. The small chapel I believe to be a very legitimate kind of drawing, but one which certainly starts to explore the realm of color — one color at the present, but with the anticipation of more to come. We go into this more fully later. Meanwhile, the drawing in question is less an architectural drawing than a drawing of light, and drawings of light are just as legitimate as any other.

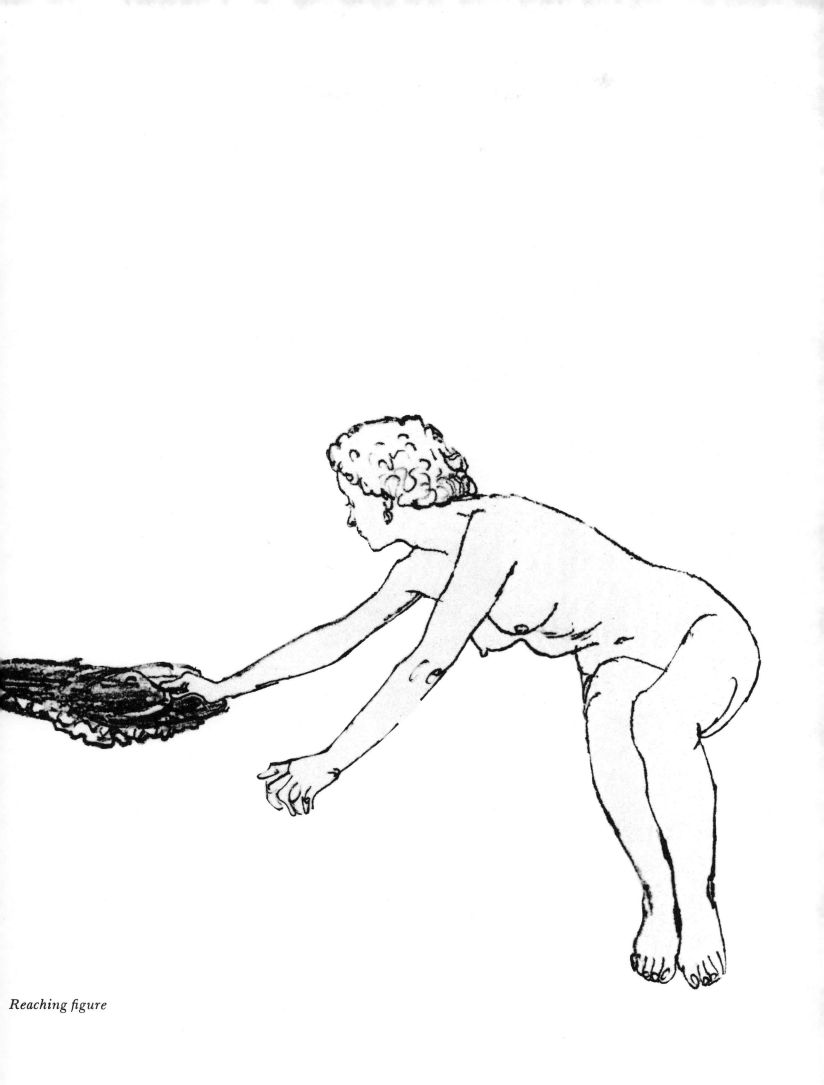

Reaching figure

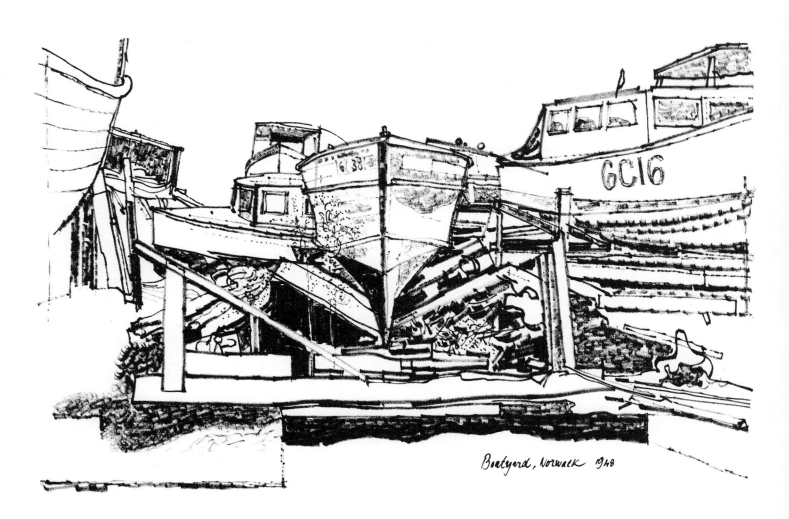

Boatyard, Norwalk 1948

7. *Drawing as Understanding*

The student drawing from the figure should not be puzzled because his model, although well developed, seems to bear only the slightest resemblance to, say, Michelangelo's study for the Libyan Sybil. Remember that Michelangelo's studies were largely imaginary. For the Libyan Sybil he seems to have used a male model for what turned out to be a female figure. He was drawing directly from the model, but his observations were guided by a preconception of what he wanted. His was a positive attitude in which imagination was not subservient to the eye. The eye in his case was a contributory adjunct, aiding and giving authority to feeling and knowledge.

The student may well ask why, if this position of dominance is the sign of the mature artist, he is being told here to assume a posture of complete subservience to his eye, to obey it and to learn from visual observation — how, in fact, humility at the beginning can lead to the assurance that the artist in him is functioning. The answer can only be that this will come with the knowledge of his own growth. Human sight, as has been said, is possible of such development that the artist's temporarily frustrated ego will eventually assert itself. And when feeling enters to distort and even to caricature, to give emphasis to what is important and ignore what is trivial or trite, then the student is becoming the artist.

The essence of good draftsmanship seems to be to "make oneself understood" on paper. It deals with clarification rather than confusion, and substitutes meaningful delineation for vagueness and indecision. Although the increasing complexity and subtlety of a problem will require a similar increasing subtlety of means, and therefore greater technical command, I think you will find few fine drawings which do not subscribe to this definition.

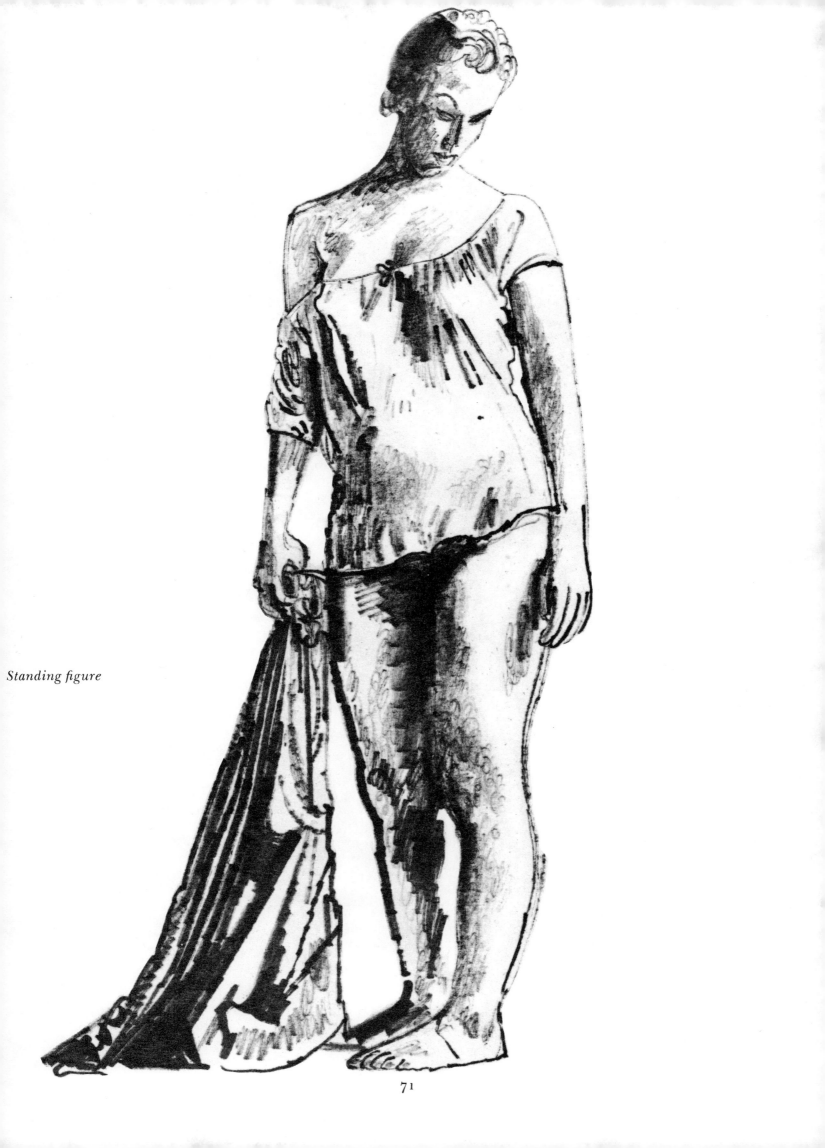

Standing figure

With practice, one comes to recognize what one is looking at as either primarily linear or tonal, and one comes also to know whether its structural characteristics are predominantly angular or rhythmic. It is upon this one bases *the statement*, for that is what a drawing is — a simple, pictorial statement.

Whenever possible it is best to make the statement a positive one, but that can only come with the confidence of understanding what you are drawing, and what you want to say about it. This in turn only comes after unremitting practice.

A drawing started tentatively rarely gains vitality later, while the bold statement, however preposterous, often has its own humor and flavor.

The thing well drawn is proof that it was understood. If it lacks conviction then the only thing to do is go back and look at the subject again.

Children seem to show this understanding in their drawing. Although they often accompany them with torrents of oral explanation, children's drawings can usually stand on their own. It is sad to see a natural outpouring so often lost when the child starts to notice and then to imitate the more vulgar kind of drawing in the popular periodicals. Later it takes years to regain and develop the talent.

A figure study, boldly stated by observation of the way light plays on it and reveals the form.

Hiroshima 1945

I have never placed too high a value on natural aptitude. It seems likely to me that if one starts early enough, maintains a keen desire, and implements this by constantly drawing, he will end up by becoming a good draftsman, or at least a draftsman. (A friend of mine contends that even to be mediocre is difficult.)

One faculty that only experience can develop is the ability to differentiate between excellence of the drawing and the interest inherent in the subject itself. It is difficult at first to rate the beautiful drawing of an apple before the commonplace rendition of a pretty woman, but that will come. We implied earlier that to believe otherwise would mean that the artist drawing from more interesting subjects would automatically produce the better drawings.

Choice of subject matter is often a matter of taste — but the kind of taste better displayed by the interior decorator than the artist. If we are talking of saleability that is another thing, but we are not.

I think it can be said that seeing and understanding are one and the same thing, or at least interchangeable. In conversation we say, "I see what you mean," meaning, "I understand what you mean." In drawing the same thing applies.

In the presence of most pieces of art an unconscious communication goes on between the work and the onlooker. It is not a transfer of information, but more a natural agreement of meaning on a highly abstract level. Something similar must also take place between the artist and his subject before what we speak of as the understanding of that subject can be recorded. A little later I will speak of it as a desire to make a *comment* upon it, but earlier in the training stage the idea is more to *know* about it, what are its peculiar properties and what its particular significance.

This artist will find out the more carefully and searchingly he looks, and the more he finds the subject eluding his ability to record on paper, the greater should become his determination to persist, until disgust at his own attempts gives way to a tolerant acceptance.

The artist cannot communicate unless he understands, and the moment of understanding becomes the moment of communication.

All this is perhaps a more complicated way of saying that drawing only comes about by drawing, not by theory, not by shortcuts, and certainly not by eccentric experiment — but simply by drawing. Why students of the subject ever find comfort in reading about what is really a higher form of communication, I will never know. That there is little comfort in writing about it, I do know.

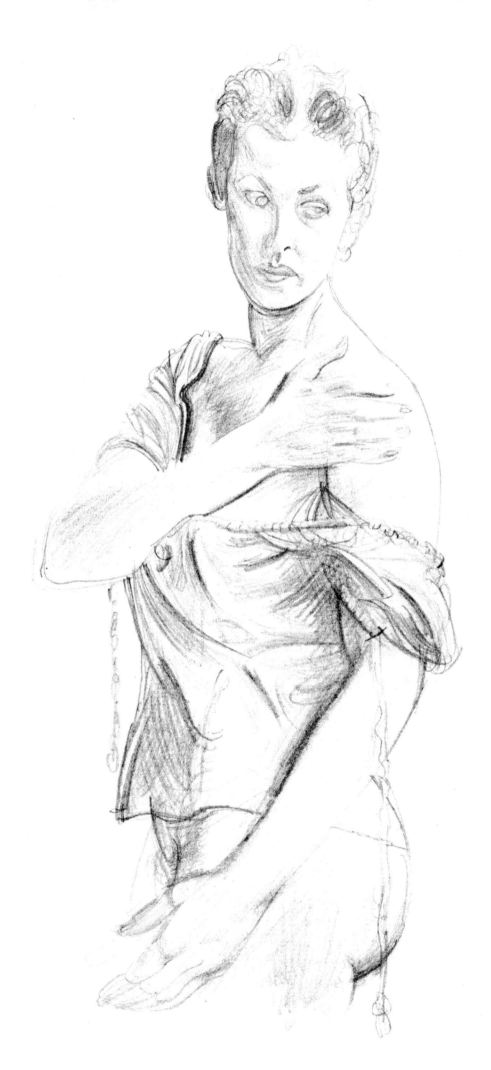

Figure - pencil 1957

8. *Round or Flat*

As we said earlier, the present argument is designed primarily for students of the graphic arts. Yet sculptors also draw, and theirs is a different kind of observation because they need an entirely different set of facts.

When I was a student in London, our life class was visited each day by a different instructor — a procedure designed to prevent standardized criticism.

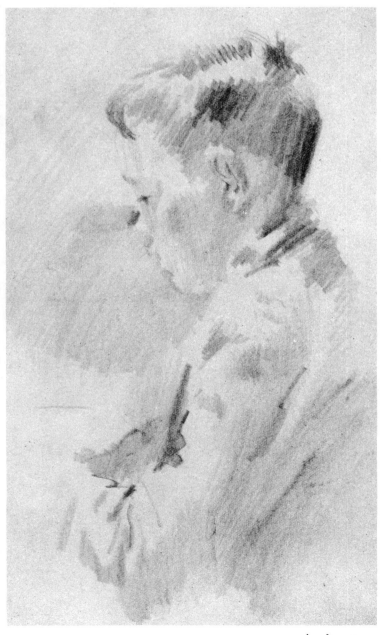

pencil, 1923

These instructors held views which were often diametrically opposed to each other. After the first confusion the student was forced to arrive at conclusions of his own. One day one's drawing might be criticized and the criticism "proved" by a complicated anatomical diagram. The next day's instructor would say, "I don't know why you worry about anatomical structure. Just take your pencil and put down what you see," which he would proceed to demonstrate with quite extraordinary results. His point was simply that in order to see and record the surface you do not have to necessarily know what goes on underneath that surface, a quite revolutionary idea in an art school devoted to the classic theories of drawing. The point was, of course, that in order to see the surface of anything, you had to develop a keen eye — a training which too much reliance on a rudimentary knowledge of anatomy often prevented rather than helped.

The logic of this approach made an immediate appeal to me, and after a short struggle with a conscience which said that since this was a revolutionary idea it should be suspect, I gave in, and developed seeing to a point where everything I saw became a picture. This idea is introduced here in the hope that the reader will examine it and either reject or develop it to a point where it has an application to his own growth as a draftsman.

Simply stated, it is the difference between the sculptor and the painter.

As we said, the sculptor sees things in the round and is concerned with solid shapes. Pursuing this, and distilling it through the artist's personality, he arrives at the form. It will not necessarily be the form originally seen. Modifications, selection and distortions will enter and the result may become something only remotely resembling the original.

The painter, on the other hand, is concerned with the object in a setting. With color and tone and on a flat surface he must create an illusion of the object in space or depth. This calls for a different quality of

seeing, and although the present discussion is limited to drawing, that limitation is largely arbitrary. I believe there is a tendency to start painting too soon, and it is better to draw until the absence of color becomes unbearable. By that time we should have built up an appreciation of what it is designed to do, and the transition will be a graceful extension of a practice already well advanced.

I recall even now the admonitions we received in class to "keep that delicate eye for color" and "never kill the light," when all we had in hand was fairly hard pencil and white paper. What this resulted in for some was a kind of "pointillism" in one color — the technique of the French impressionists. This may sound rather dated now in the light of the trends painting has since taken, and I state it here not as an end, but as one step away from conventional modeling and toward "picture seeing."

We are committed, in a way, to the elimination of muddy thinking on this subject of draftsmanship. If I urge that much should later be forgotten, it is because I am aware how closely all this borders on dogma. But remember that muddy thinking in drawing too often results in empty marks on paper. What we are striving for is that everything put down should have meaning — should, in fact, be eloquent.

It might seem that in dividing drawing into two categories, that of the sculptor and that of the painter, we are unnecessarily complicating our approach. So many drawings of the past and the present seem to resist this kind of arbitrary classification — and rightly so. But it is an important differentiation to consider, and my reason for stressing it now is because of the hundreds of large, often extremely competent, sustained studies one sees every year by students who after leaving school, seem to be unable to apply an aptitude so dearly gained. Prize students falter and fall by the wayside and finally drift into occupations only remotely connected with the one they thought they were training for. I believe much of this talent can be salvaged with a little purposeful thinking.

Nothing said here of course applies to the "wunderkind," the one who never seems in any doubt as to his direction and who pursues it relentlessly. In schools these are the sports who make all curricula seem silly.

But for the large mass of us who are not of this fortunate breed a little cerebration, it seems to me, could avoid considerable perspiration.

By reducing our seeing to the flat, by starting to experiment early with the kind of work this leads to,

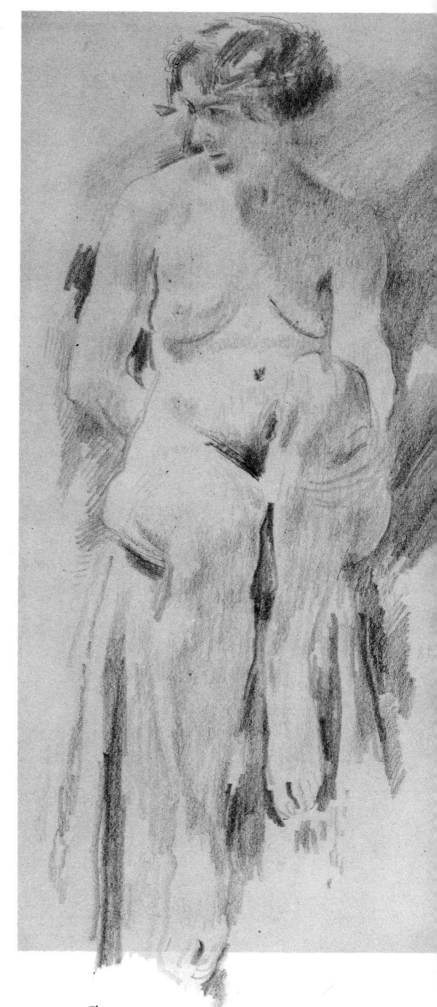

Class Study 1924

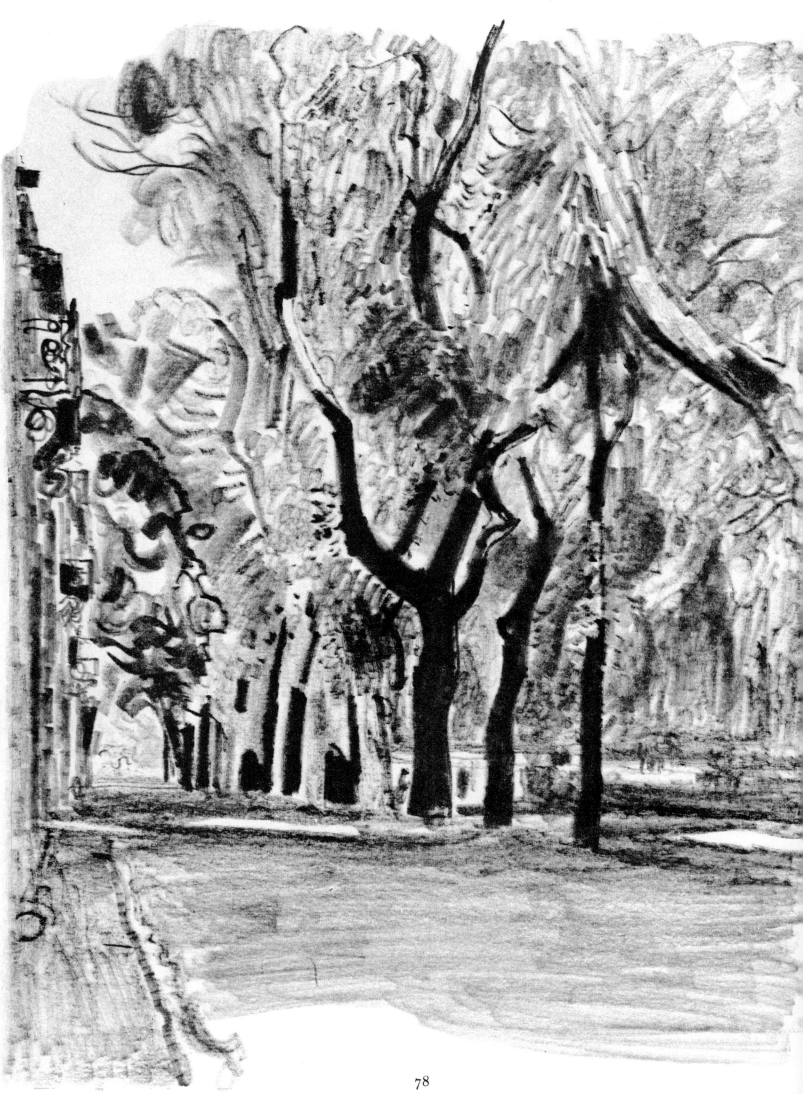

Sunlight Through Trees, Nimes

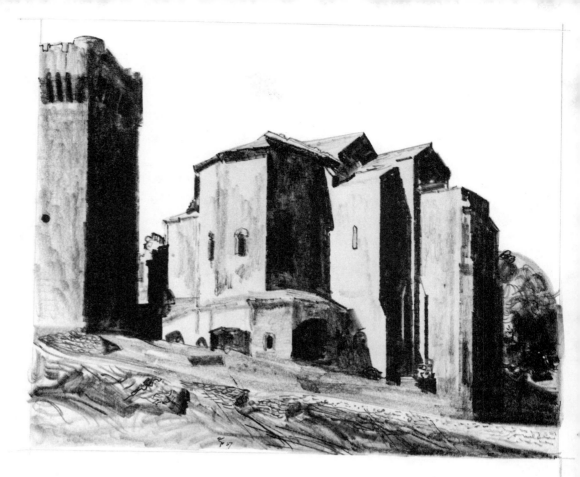

I think it is possible to avoid falling into the rut of copying. By occasionally deciding to draw solidly and roundly, modeling form as though we were working in clay, and following this by a further period in which we ignore solidity and simply paint with the pencil, tone for tone, edge against edge and texture for texture, we are made aware of the extremes of thinking embraced in the simple word drawing. This should tend to break down whatever barriers have been hampering our development.

The drawing pencil will soon give way to paint and color, and although we have insisted on modeling the isolated form in the round, it now becomes possible to do the same thing more easily and I think more interestingly. I do not believe the earlier thinking and training should have been bypassed. This new concept of drawing in the flat is itself only a temporary idea, as the artist develops his own language and uses from his total knowledge only what he needs.

I say this knowing that the worthwhile drawings will come from the draftsmen who break the rules — after, I may add, first mastering them.

If you are, as I am, thinking of the many drawings we admire which seem to contradict all dogma, I wonder if a closer examination will not reveal that this appeal is largely one of subject matter,

something which it will be ours to choose freely later but which would only confuse the issue now.

Many of the landscape drawings which accompany this section were the result of a trip to the south of France and to Italy. Here I found ample proof of the validity of drawing by light, for the bright sun allowed of nothing else. Some of these sketches, often drawn under difficult conditions, not only identify the subject, but also the light and atmosphere of the moment (as we pointed out earlier in connection with drawing under artificial light). There is little attempt here to design the light; except insofar as long and instinctive habit automatically dictates selection and chooses observations.

In the drawing of sunlight playing through trees (opposite) the only objective was to record the spontaneous excitement and rhythm of a fleeting moment which would never have responded to prolonged analysis.

In that of the deserted abbey, the mid-morning sun revealed the majestic and solemn interplay of forms. The brilliance of the light permitted of no middle tones, but sharply divided the vision into the simplest statement of light and shadow. One is, it is obvious, painting in one color, an excellent preparation for painting with a full palette. I find myself wondering where that cry for the study of human anatomy fits in here. I know the automatic,

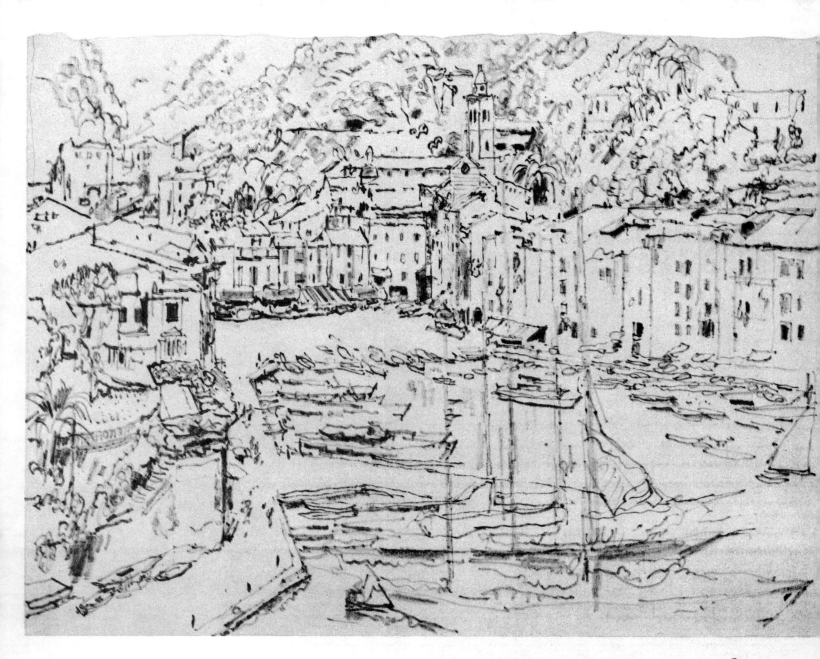

Portofino

but incorrect, response is that human anatomy is the proper preparation for figure drawing. But if this is so then why should not this kind of drawing be preceded by a study of architecture, or that of the trees by a course in botany? I think that if we stop trying to pigeonhole the different kinds of drawing, we will the sooner accept an all-embracing concept which admits of no such artificial divisions. The juxtaposition of unlikely examples throughout this book may tend to create some confusion in the minds of those who find safety in category but, as I indicated earlier, it was designed to do just that.

With regard to these and other landscape drawings throughout the book an interesting thing happened to me. I had felt that for artists to go traveling laden down with cameras was becoming a pernicious habit. They arrived home with hundreds of still pictures, few of which were ever looked at again after the second showing. Because of the ease with which these were taken, little if any visual digestion had taken place. So I took along pencils and felt pens and a variety of paper. I was determined that if a thing was worth photographing it was worth drawing. This did not prove to be so, and at first there were false attempts to draw subjects which after a few minutes proved to have little if any visual interest to the draftsman. It was an interesting discovery for me to realize the extent to which our vision had become so conditioned by contact with photography that we are in danger of seeing the photographic

subject as the only one. I cannot quite describe the difference, but it occurs when one finds one's self drawing with no enthusiasm or excitement something which only minutes before had seemed of exceptional interest.

The one distinction is that the artist is drawn to something about which he wishes to make a comment, the layman is content to record the subject with no comment. There are of course photographers, such as Henri Cartier Bresson today, who use the camera in much more than a reportorial sense, but these are few. This ability to comment, for that matter, is equally rare among painters.

The layman will always carry his camera with him. For him it is the means of having for the future a nostalgic record of places visited and of experiences tasted. But the artist's experience should be more than that. Visual impressions should undergo the evaluation of his own taste, and for him this is done by drawing or painting.

The drawing of an Italian hill-town at high noon, with a wall coming down to divide the composition, is nothing more than a record of that scene. Leaning on the wall and looking out over the town below, I simply took out the felt pen and started drawing what struck me as a composition which broke all conventional rules. In spite of the heat, the subject began to intrigue me the longer I drew, and now it does seem to have a kind of presumptuous humor of its own.

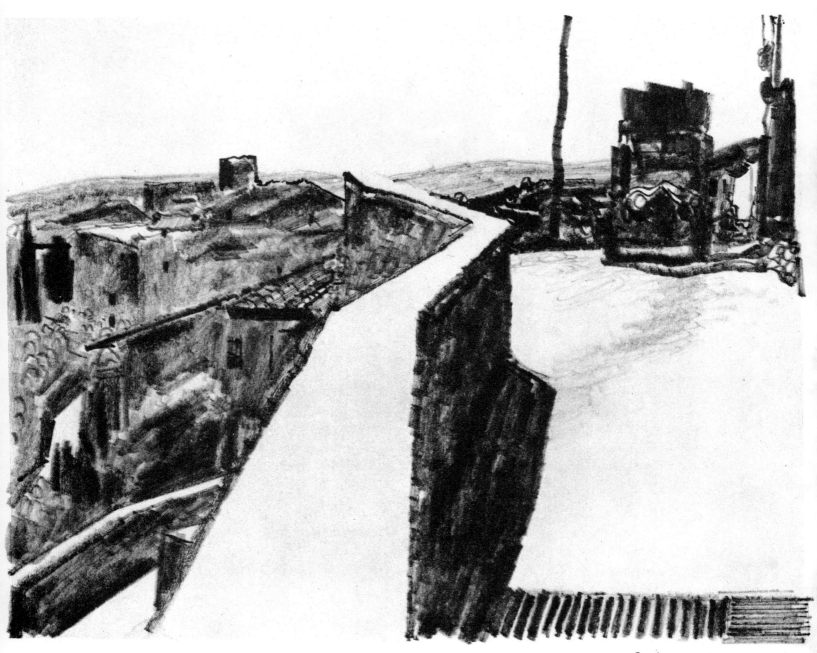

Sunlight . S. Gimignano

81

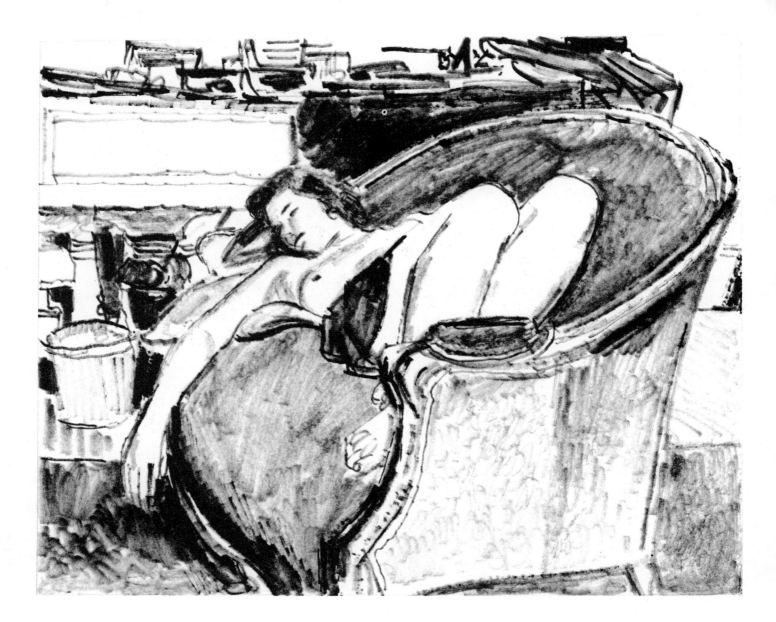

9. *From Light to the Scene*

Eventually the drawings you do will conform to neither one nor the other category exclusively. They may be a combination of "modeling the form" and of "painting with light" or perhaps something entirely different.

But the great fault with most drawing stems from a refusal to commit oneself one way or the other. The result is a tortured attempt at a bare approximation of what is seen. For instance, it is difficult to draw under artificial light in an evening sketch class or in the home. The harsh light or lights create so great a confusion of shadows and reflections that it is almost

impossible to see the solid form. There is never any doubt, looking at the drawing later, in deciding under what light conditions it was done. We come away wondering why the drawing lacks sculptural quality, which was of course very unlikely with the subject lit up like a Christmas tree. Under these conditions it would be better to abandon the idea of modeling solidly, and instead give oneself over to painting with the pencil all the subtle tonal nuances which artificial light produces, without reference to the actual form. The result will not only train the eye, but will show the model not isolated, but in a

setting, including the particular light conditions of that moment.

Drawing under natural light, on the other hand, particularly the cold north light of a studio, allows one to explore forms more completely and to model solidly. Quick effects are more difficult to come by and although the resultant drawing may look a bit pedestrian, the student will, I think, gain great competence this way.

You will note that I still stress accuracy of observation as the jumping off point. One is not interested at this stage in the idealized drawing. This latter concept, a romanticized mask in place of the searching character study, stops keen observation and can eventually be done just as easily with no model at all — by following a formula.

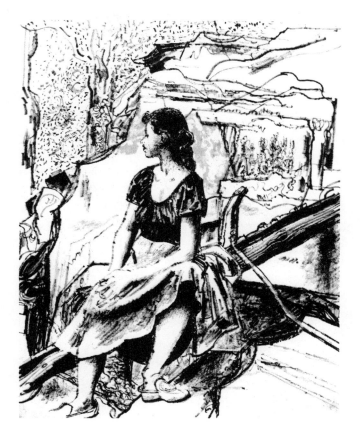

One other thing to remember at this time in the division between "modeling the form solidly" or "painting with light," is that whichever one does, one should do it with conviction. Drawing by light ignores solid form and matches tone for tone and then proceeds from the isolated object to the scene around it and finally ends by drawing and designing the entire picture within an imaginary frame. It requires the keenest vision, but with practice one forms the habit of thinking in "picture" terms. Composition is not then a study one must take up later — it follows as the natural extension of what is already being done. Drawing and picturemaking become one.

To demonstrate this let us assume for a moment that we are not ready to go beyond the figure itself. We have been isolating the model from the total scene for special study, although since the primary object is not to "learn the figure," but rather to *learn to draw,* there is no logical reason why we should do so. As stated earlier, in drawing from the model we are accepting a convention which has gone on for many years. It is, we said, entirely conceivable that one who has spent a long time in complete isolation, drawing continually from the simplest object, such as an egg or an apple, could arrive at such a degree of competence that, finally confronted with the human figure, he would have no difficulty whatsoever recording what only amounts to a more complicated, but not essentially different problem. This is not only conceivable, it is probable. When Cézanne turned from painting a still life to apply himself to a portrait, he did not bring with him an entirely new set of convictions. Perhaps his palette changed slightly to accommodate itself to the new subject

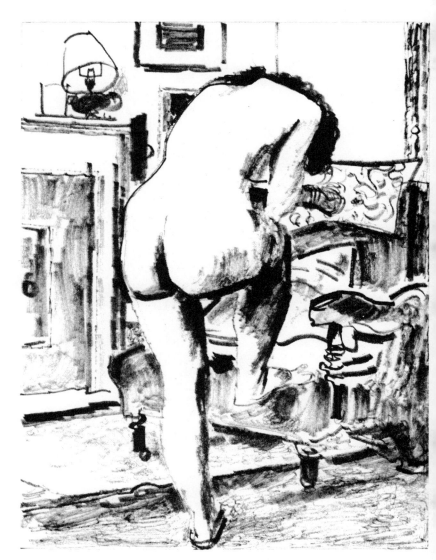

matter, but his painting concept remained the same. He painted the head today just as he had painted the apple yesterday, without sentimentalizing about it merely because the head could talk, and the apple could not.

With this in mind we should wait before putting down a line to delineate the edge of a form and see whether it would not be more truthful to put down the tone behind the model, for which the line is merely a simpler convention. If we start concerning ourselves with head, arms, legs, etc., we are allowing the mind to become *inventorial*, we have started to count, we will soon be in difficulty. If instead one allows oneself to see "in the flat," and naturally record the figure as a variation of tones, shapes, and directions, then it is quite as simple to go beyond the limits of the model and start to record the whole scene.

The curtain and wall beyond, the stool and the discarded robe, the edge of a doorway — all contribute to the picture, and the result will be a scene of which the model is only one element. The figure will have been placed in an environment, with space all around it. In short, the student of drawing has, without changing pencils, started to paint the scene, to design pictures, and is doing it more naturally than he had ever thought possible.

It may sound illegitimate to arrive at this stage without sweat and travail, and in truth it is distinctly easier to describe than to do. Much work and time will be expended before it comes easily. But it will come, and naturally, and that is the easiest way in the end.

Consider the advantage of being permitted to discard outmoded and illogical observation while still in the life class, to avoid the conflict which comes from the inability to reconcile old academic practice with modern aesthetic ideas. It is a step that the lively intelligence should not allow itself to forego, and the relief can now be demonstrated by plunging with all enthusiasm into the fascinating world of three-dimensional seeing.

With development of the ability to "see pictures," instead of arriving at contrived compositions, the problems do become complicated. The artist must assume control or become the victim of his own confusion. For now when everything seen becomes a picture, the choice between good or bad pictures has to be faced.

But since the creative impulse has not been dissipated on inconsequentials, or on stupid outdated thinking, it can be said to have been held in abeyance for this moment. The artist must now dominate his own sight. He can allow distortion to enter, and insist that pattern, form, and later color, assume aesthetic order and rightness.

Form can be revalued and restated. Freedom supplants the discipline which has heretofore been followed. The laborious artificial still lifes and figure compositions, both academic and the pseudo modern, can be relegated to limbo, as the excitement of spontaneous vision replaces dull exercises in technique.

The world of painting is suddenly opened to reward the student of drawing who began by following conventional beginner's practice a short time before, but who was too alert to be deceived into believing that either academies had the last word — and who was not afraid to put the logic of his thinking into practice.

Perhaps even more important is that the artist now has a knowledge of form which is his own. He should now be unafraid to look at anything, and all selection and distortion will be dictated by a comprehensive knowledge of *the way things are*.

He should never again be tempted to adopt the mannerisms of some currently popular painter. The draftsman's drawings will have no need to ape the artist of the moment, nor will it be incumbent upon the illustrator to follow trends set by others, for if there is one sure way to mediocrity it is to allow oneself to be influenced by others and to allow that influence to show. The artist will be often pressured to do so by unscrupulous people who see a way to gain a momentary advantage, or by buyers who are unable or unwilling to secure the original, and will settle for a pale imitation.

But this is not the way to artistic maturity. There is an old German saying *Kleine, aber mein,* small but mine, and this is the more rewarding idea to keep in mind.

You may see now why the text of this volume has so strongly emphasized seeing things clearly, recording them honestly. If it had included the tricks and shortcuts, the ways to achieve effects without understanding, it might have gained a quick momentary popularity. But these tricks are child's play to the draftsman. To anyone for whom drawing is a passion, whose eyes are constantly searching and evaluating even when he has no pencil in hand — to that man tricks and techniques have no appeal. He sees them for the superficialities they are, and in doing so rejects them.

Cornledge. Conn.

85

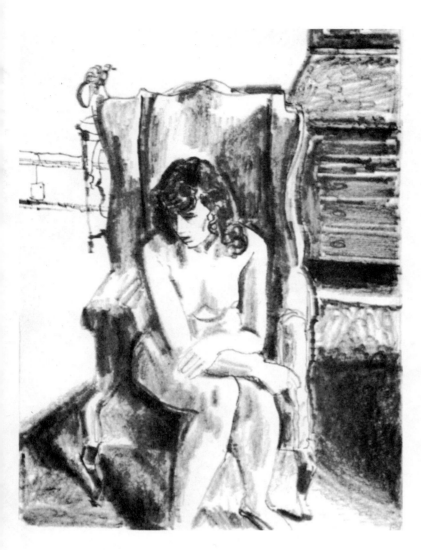

This is what our whole discussion of learning to draw has been leading up to, for if we had been content to stay back there noodling and polishing simple figure studies, they might now be blinding in their degree of finish, dazzling as exercises of virtuosity, but we ourselves would be neatly trapped in that comfortable corner from which so many students fail to find the exit.

Assuming that the student draftsman has been drawing constantly and that his eye and hand have gained a considerable degree of proficiency, to go back to that kind of study is easy, but uninviting.

Do not misunderstand me, the isolated study — be it of the figure or anything else — will always be useful, but since we are now starting to design pictures, the isolated studies must also be designed. Thinking in picture terms changes one's outlook so that every element within the picture breaks into the same terms of pictorial design as the over-all picture itself.

Drawing from nature now becomes a different thing. We start designing within the object or figure, selecting and emphasizing those things which are of immediate interest and need, rejecting the others.

The keen eye and hand now become subservient to taste and selection, in short, in a creative way we are now on our own.

As observation free-ranges over the entire scene, pattern seems to be the dominant interest which holds everything together. By seeing everything in terms of pattern one is capable of feats of perspective without this ever becoming a conscious problem. The subject at ten feet and the background at ten miles can be seen together simply as two contrasting shapes. The juxtaposition of these shapes becomes of all-engrossing interest, for we can now start designing as we observe.

It might seem that this does not differ too much, if at all, from the conventional method of arriving at pictures—that is, by taking the separate components and organizing and arranging them. But it is a completely different aptitude, for now the picture is arrived at spontaneously. Also let us be reminded that while we are talking about pictures — and therefore inferring painting, this is still a simple treatise on drawing, and the medium is being called upon to do things not commonly associated with that term. Without changing the media we are deep in the painter's territory, and when we do go into color we should do so without a lot of the floundering which usually accompanies the student when he is faced with a complete spectrum. This latter is like being faced with conducting a symphony orchestra after a period of preparation on a piano.

Although we have talked about drawing up to now as a preparation for something else — as an aptitude to be gained on the way, it is interesting to see that the drawing we can now do is a far more comprehensive thing. It approaches the art form which at the beginning we told ourselves we would avoid for fear of becoming too deeply involved in aesthetics. Drawing now leaves the category of sketching, or preparatory study, or informative diagram, and seems to be opened up to an almost limitless degree, and still based on the thing observed.

I was describing this to a student recently, and although apparently impressed with the logic of the argument, which I was able to demonstrate graphically, he seemed puzzled and a trifle disturbed because what I had been saying he construed as realism; whereas most of the paintings he saw (and here he became vague) were "a kind of abstract

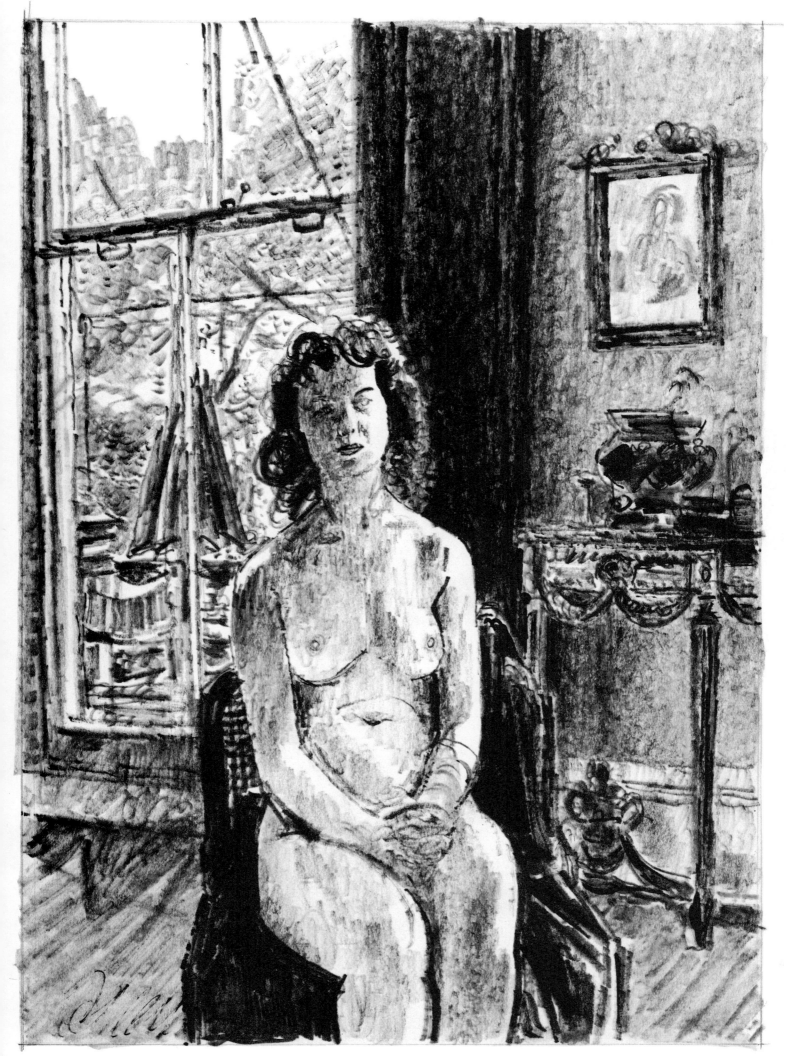

Interior with figure, London

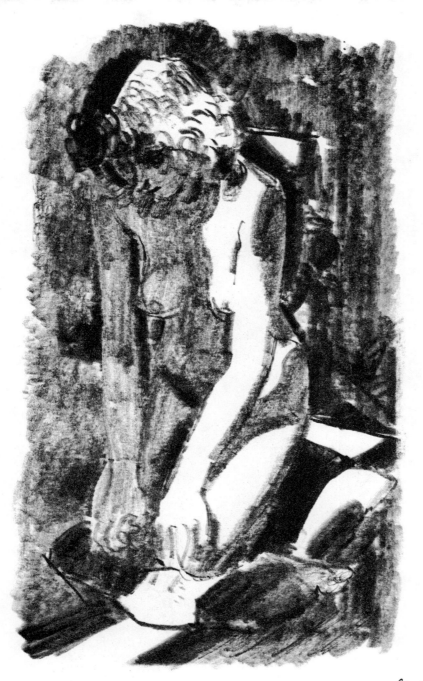

Kneeling model

modernism (sic)." Evidently he felt the necessity of being in the swim, and mine was not it. This viewpoint demonstrates two misconceptions. The first is that abstract qualities are new to contemporary painting, whereas they have been the comparison of excellence since painting began. As to the use of the word *modern*, substitute the word *contemporary* and it embraces everything currently being produced, good, bad and indifferent, so the word in this connection has no meaning at all. The statement was only another example of the confusion into which the current critical jargon has led us — that and the fatal need to conform, even in eccentricity. It was interesting for me to be able to take the scene we

were at the moment facing, which was a commonplace one, and draw it as it was. Then by subtle rearrangement and restatement of the forms, a reconsideration of emphasis within the pattern, a reduction of other elements to flat pattern and the elimination of discordant notes, finally arrive at a composition in which little was recognizable, but in which a transformation had taken place which seemed to satisfy the student no end.

At the risk of becoming repetitive, I am reminded again of the earlier quote from Reynolds' *Discourses* — "I very much doubt whether a habit of drawing correctly what we see will not give a proportionable power of drawing correctly what we imagine."

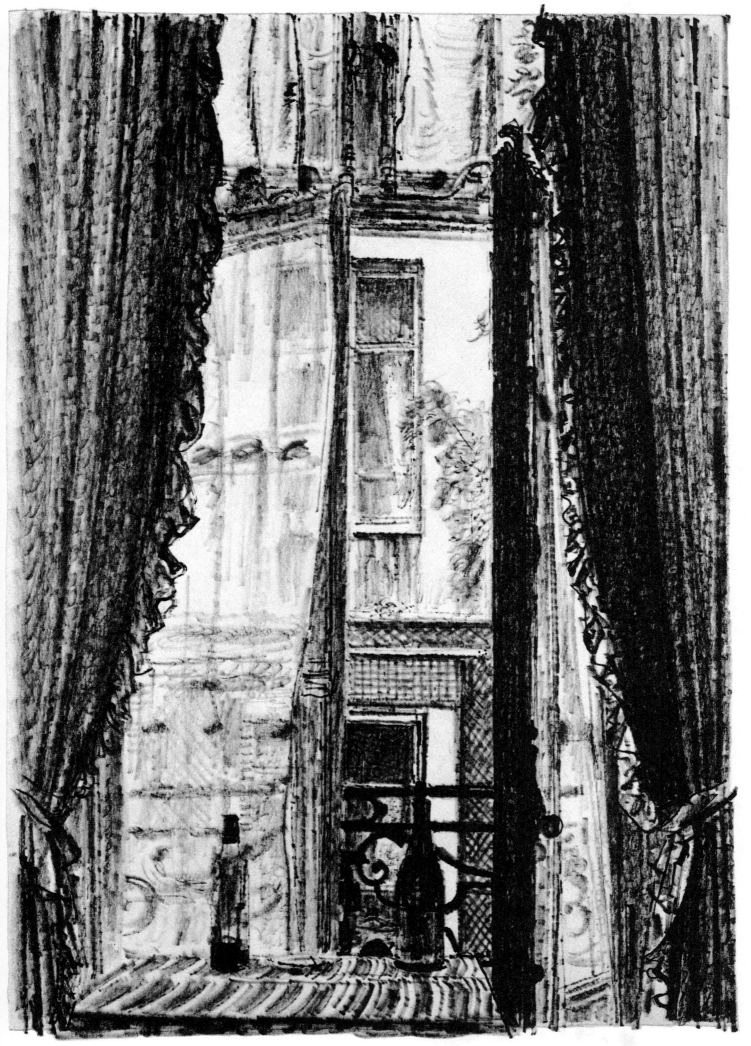

Hotel window on a court, Paris

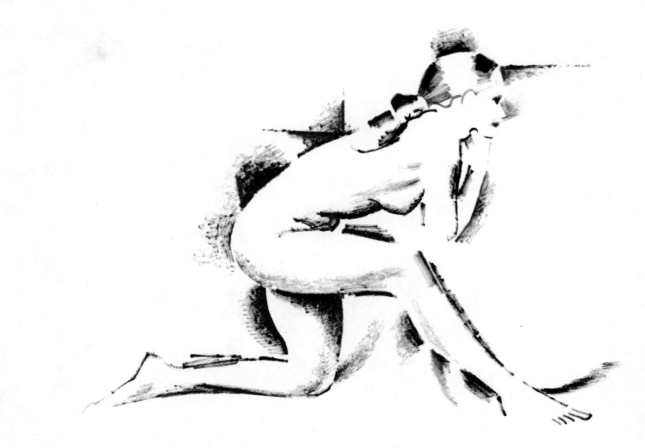

1

The drawing above is one that could have been
done by any fairly advanced student. But in the use
of outline much of it is a convention.

2

Closer examination reveals that the line used
to define an edge is actually tone meeting tone.

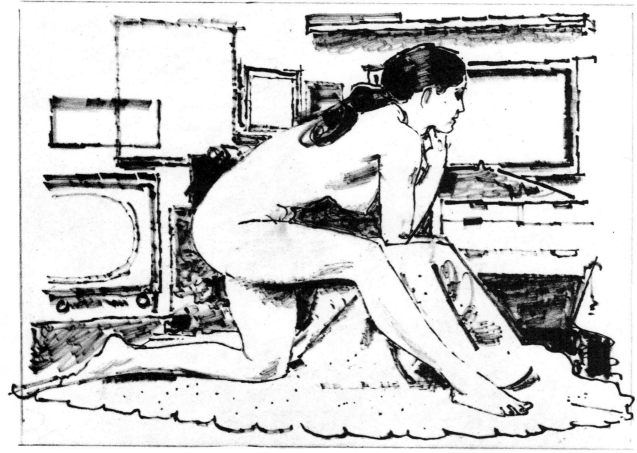

3

*With this in mind we go beyond and
begin to articulate what makes up these so-called
background shapes.*

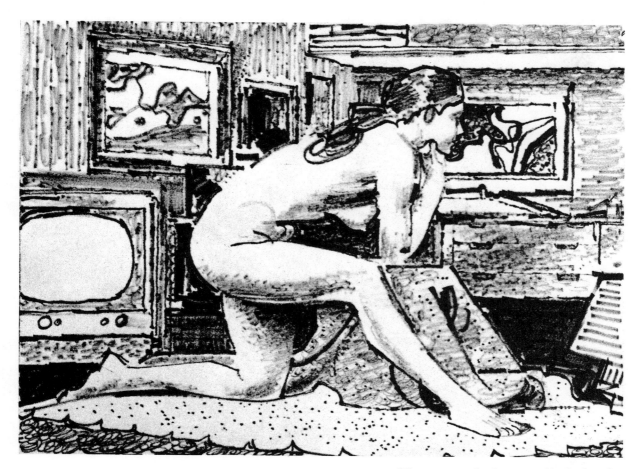

4

*We now need a frame to limit the observation,
but as everything within it starts to function we deal
with the scene, and begin drawing in terms
of the entire picture.*

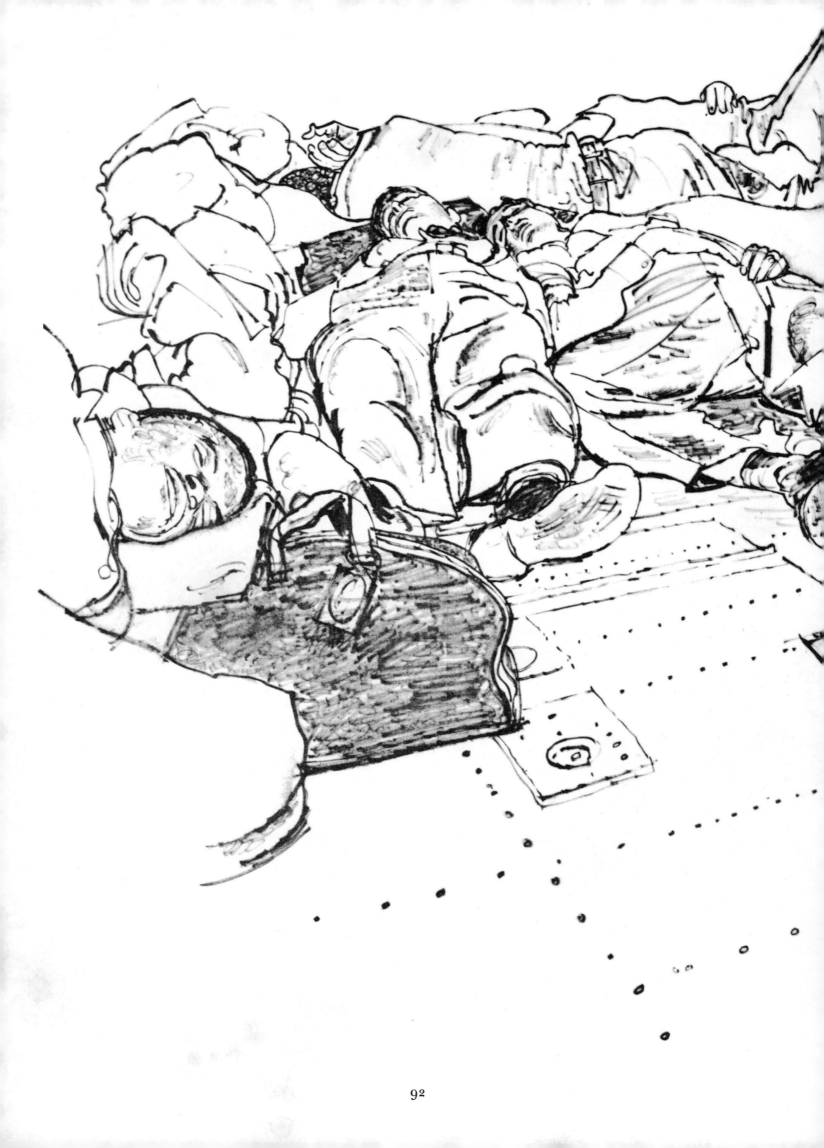

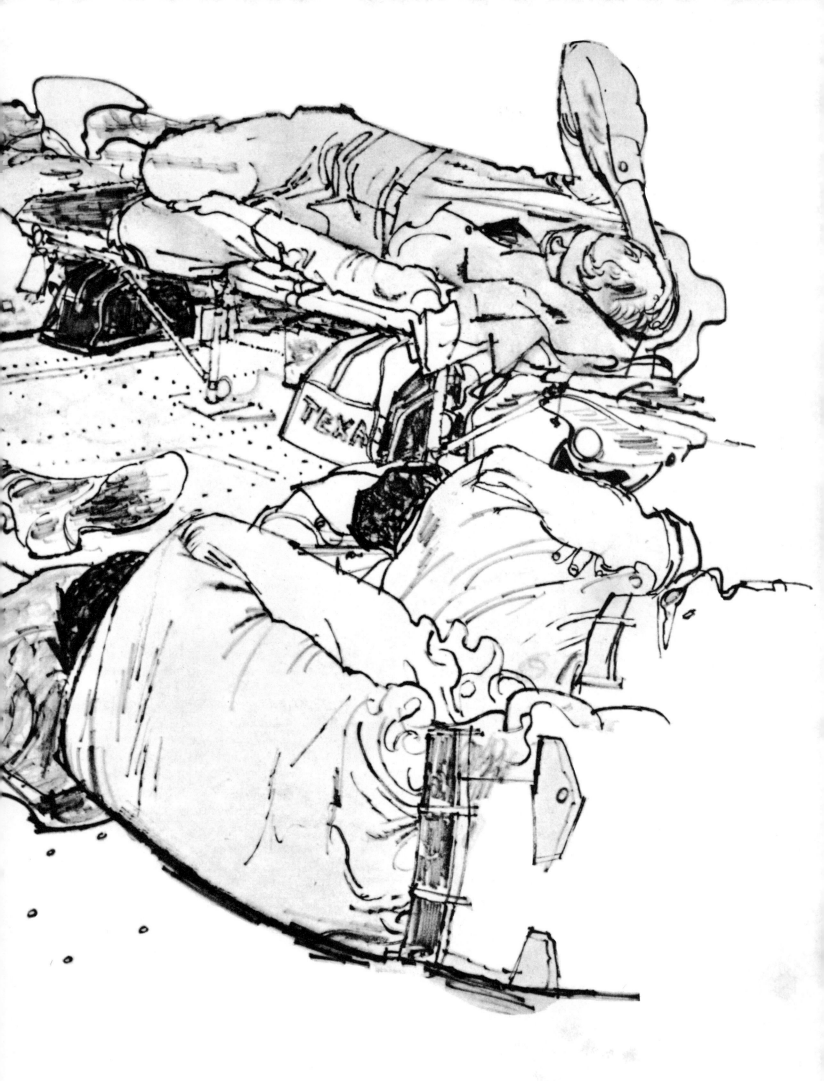

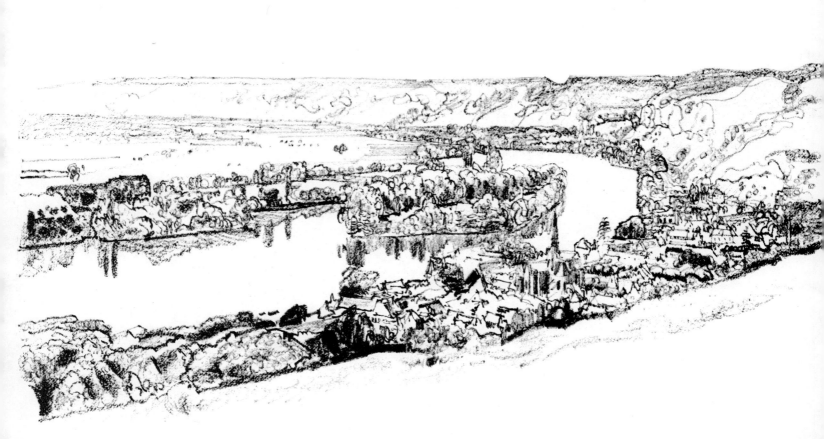

The Seine. Normandie

10. *Taste*

Anyone preparing to draw from nature, whether it be a landscape, or objects, or the human figure, makes preliminary decisions which for want of a better word seem to imply the exercise of taste. One is inspired to draw the landscape from one of several positions and to reject the others. One arranges objects until their positioning is somehow a happy one. The model's pose is rarely chosen without changes of position or lighting, until finally there seems to be sufficient incentive to sit down and proceed to the drawing. Logically, any of the rejected aspects would have been all right, but the final pose and arrangement is somehow more felicitous and the study is approached with more enthusiasm. The resultant drawing is more or less successful because of these moments taken to please the senses beforehand, so in all fairness, we must consider this process as an aspect of drawing itself. Why otherwise does the monitor of the life class decide on the pose? Why does the student walk around the room before deciding where to seat himself? Why also do some models inspire enthusiasm and others the reverse — and not always the same response in everyone?

Why, for instance, do I decide in making the drawings which accompany this text, to draw from the nude sometimes, to half drape or fully drape at others? Why have I used female figures more often than male and why, since anatomy is not emphasized, do I select one pose over another? The answer can only be that taste is somehow involved and taste is difficult to define. Taste is also involved in the actual drawing, no matter how impersonal one tries to be. The model takes a pose which records in the subconscious as a tube-like structure and that becomes the emphasis around which the final study takes form. An eccentric thrust of an arm forms a juncture with

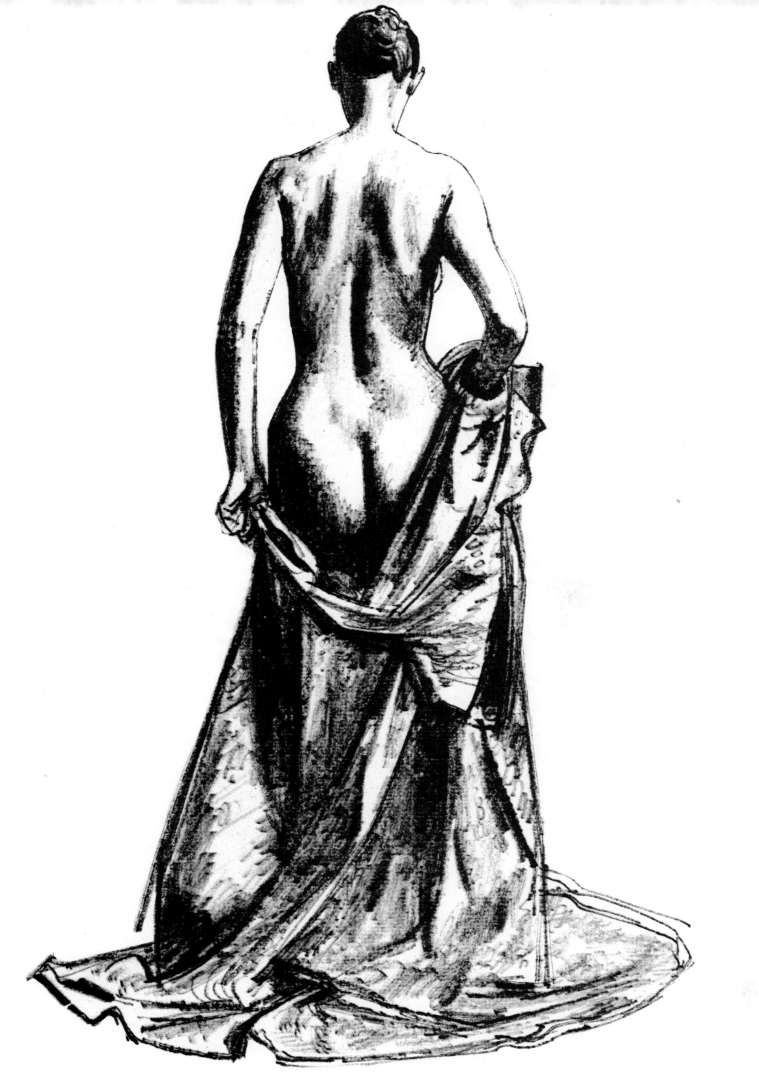

95

another form which seems to convey a subtly humorous action, and this will register as one of the aspects of the drawing which gives it character.

We have not said whether the taste involved is good or bad. We have merely noticed that something has motivated us which is difficult to isolate. I recall once seeing a student prepare to paint a study by placing a blue light on one side and an orange light on the other side of his model. I suspected in this case that the taste was bad, and I remember being saddened that he was unable to see enough to warrant painting without this mechanical stimulus. But except in extreme cases

like this I think we should be careful not to be too positive in making decisions about someone else's taste.

On a different level I have recently been studying a favorite drawing of mine by the English artist, Augustus John. Heretofore, it had simply been to me a fine drawing. But now, on further examination, when I see the trouble he went to to clothe the model in a graceful gypsy garment, and to supply a gesture of the hands which must have been a deliberate decision, I wonder whether the drawing tells more about John as a great draftsman, which he is, or as a romantic, which he also is.

I think it better if we do not go too far into this field which is aesthetics. Let us be grateful that the decisions described are ours to make. If the artist is not a good draftsman, and the drawing is insensitive, no amount of preliminary posing and lighting is going to alter it. If it were not so then the artist able to afford the best models would produce the best drawings, which is nonsense.

Taste is difficult to define because it is almost impossible to isolate. It is obvious that standards in taste vary with the individual. The person who employs a decorator to do his home because he is afraid to do so himself is exercising bad taste in doing so, however good his decorator's taste may be. In this case it seems to involve honesty.

Good taste is not a motivating force of the creative act. It often hampers it. I can imagine the artist whose critical evaluation is so precious that he is inhibited to the point of never putting pencil to paper.

The creative act in art is, in the current argot, an act of getting out on a limb and of being extremely vulnerable, and this involves a kind of courage which resort to good taste might easily modify. It almost seems as if the creative impulse involves a large ingredient of vulgarity to be a vital statement. Certain it is that almost every advance or change is greeted with this charge. After a time it becomes accepted, and soon the avant-garde pictures of yesterday are being used as background sets for the smart women's fashion photographers, a comedown I am sure their creators never anticipated.

In drawing, an excess of what we think of as good taste can only result in an anemic product, while the more vulgar statement — vulgar that is in the aesthetic sense — is invariably stimulating.

RF '46

gina

But there is that aspect of taste which we earlier saw operating in the choice of model, of lighting, of pose and of garb. It is extremely difficult when confronted with a drawing which excites our enthusiasm, to decide exactly how much these ingredients contribute to its appeal, and how good the drawing would remain if they could be subtracted.

I think what we are talking about is the introduction of the illustrative element into drawing, and we might ask ourselves what part subject matter plays. The answer is, I believe, that it is mildly but not vitally important. We should be suspicious of any drawing of the model in exotic get-up, and apply the same critical standards to a drawing of a canal in Venice as we do to one of a small town main street in Ohio.

It is one reason why a book such as this is more easily understood if the illustrations are more or less standardized in subject matter — that is, simple figures, landscapes, flora or still lifes. Then we know we are talking about drawing and not about subject matter.

For taste is a word too often used in a negative way, to describe what should *not* be done rather than what should be. The creative draftsman should wear blinkers, and be content to run that risk, for I am inclined to think that the creative act in questionable taste is preferable to no act at all, or even the tentative attempt. But again we risk becoming confused in semantics. We hear of the exquisite taste of one who does little more than arrange materials or textures, of the designer arriving at the felicitously agreeable moment of his particular media, or the work of the interior decorator. In drawing the word would seem to apply more to the artist who instinctively selects from the total and comprehensive vision only those observations which are pertinent to its true meaning, and who can ignore or discard what is irrelevant. If after long practice he can do this instinctively, the product will be virile. If it is a self-conscious and considered act of censorship, it risks becoming sterile and meaningless.

These are the result of sharing a studio one summer with Stanley Hayter, the British draftsman,

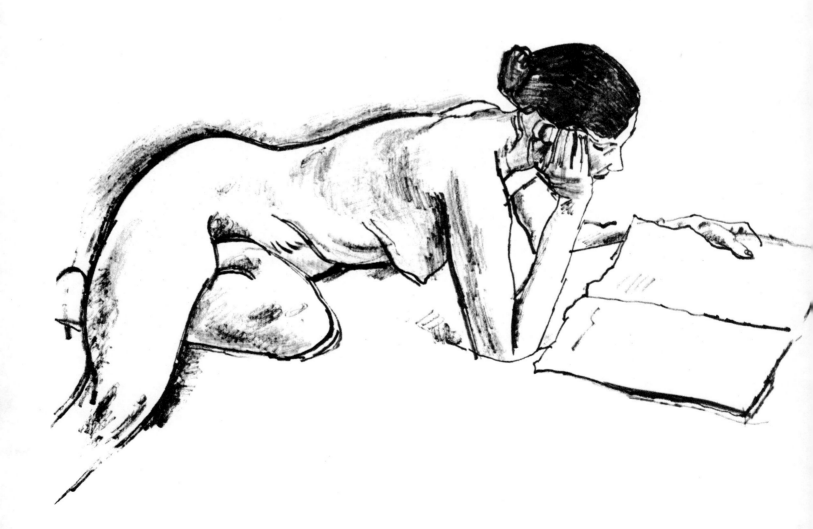

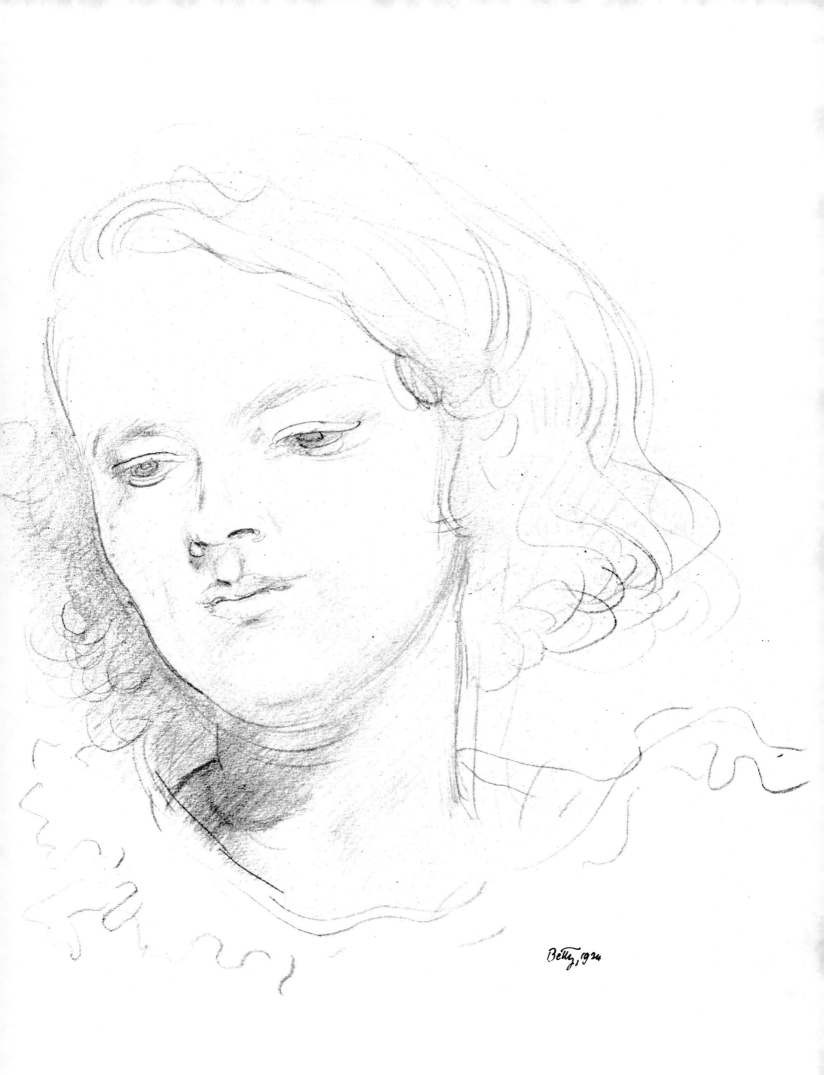

Betty, 1924

99

printmaker, and painter. It was he who did so much to influence the French painters, including Picasso, into an interest in etching and prints. I became fascinated watching him turn out his free calligraphic drawings, in rapid succession, and under his influence I experimented on my own for some time afterwards. Hayter's own drawings were completely abstract in that they were devoid of recognizable subject matter. Due to my own training, enough subject matter did creep in to allow me to title them, although this was hindsight. In drawing like this, one never knows what is going to result.

They are freely drawn with a speed-ball pen and India ink, and later amplified with crayon or other media. One starts with a full pen and simply allows

Dance

it to follow whatever unconscious prompting fancy (or taste) dictates. The only evaluation can be aesthetic, based on abstract criteria, since there is point of comparison with realistic phenomena. Th shape of the drawing is often determined simply b the shape and size of the paper. It is probably as cl to music as drawing can come, as when a vagrant theme seems to demand development, or a simple rhythmic statement calls for one in a different col like a theme in the upper register acting in counterpoint to chords in the bass. Indeed, major drawings like this often develop from notes jotted down on a work sheet, simple notations of plastic linear ideas, similar in purpose to the first themati notations in the notebooks of Beethoven.

To those not devoted solely to the idea of representation, drawings like these can become surprisingly real, and a fascinating exercise in unconscious motivation.

But because my philosophy of drawing is based the thing seen (I am more of a logician than a romantic), this influence was important but transitory. However, I recommend it as an exercis to those not afraid to experiment. A well-rounded diet consists of more than plain meat and potatoes

Homecoming

Masquerade

11. *Seeing and the Medium*

I recall when as students we were often told to think of the human figure as something it was not, such as a series of solid rectangular blocks. More recently we see those in the classroom resorting to far greater eccentricities. They draw the figure as a mechanical contrivance, or as if constructed of string, or an interpretation of it vaguely and superficially resembling a Picasso montage. However much the current critical jargon tries to justify these flights of fancy as a "release for the intuitive perception," there is no record of a great draftsman having developed except by the rigorous discipline of conventional training. In the auction sale of his studio's contents following Degas' death were literally hundreds of his early student drawings, sweated over figure studies not too different from the average of any life class today.

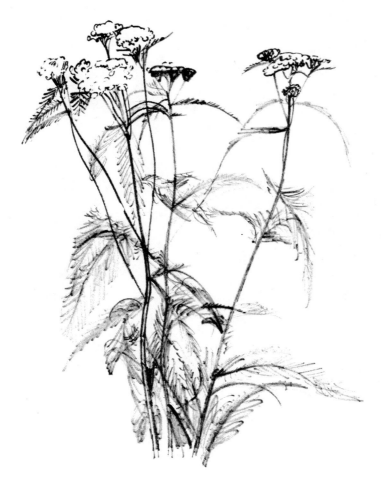

It is interesting to note that not only did Degas submit to this academic training, but that over a long career he apparently felt no need to destroy these early studies. They are all reproduced in the catalog of the sale, permanent historical evidence of the development of one of the finest and most original draftsman of them all.

I cannot understand why we should be asked to see things as distorted conventions, translating what we see into what we cannot see, when the final objective is to go back to what we see again. The same thing occurs when the student is asked to consider anatomically something which he cannot consider in any such way because he is looking at a surface, and more often at a clothed figure. The person who draws ineptly and with little sense of solidity, is only showing that in terms of draftsmanship he does not yet *understand* what he is recording. It would seem more reasonable, instead of providing a crutch in terms of these artificial conventions, to urge him to continue to look at what is before him in the knowledge that he will eventually come to see it, by which we mean *understand* it. When that time comes he will have no difficulty drawing it.

In fact there is no need to get into an emotional dither over the simple act of drawing. The strange distortions and fantasies we speak of above are completely out of place in the classroom. Eccentric theory is best avoided; we are first out to gain competence. If it does not come all at once it is no wonder, and certainly no reason to go off at a tangent in a search for easier and more spectacular solutions. These are not solutions at all, they are the self-indulgence of the impatient, of those without sufficient intestinal fortitude to persist in a direction which may not always be thrilling or exciting.

For if resort to these conventions in place of seeing were valid before a figure, then why not prescribe a similar convention for a flower drawing?

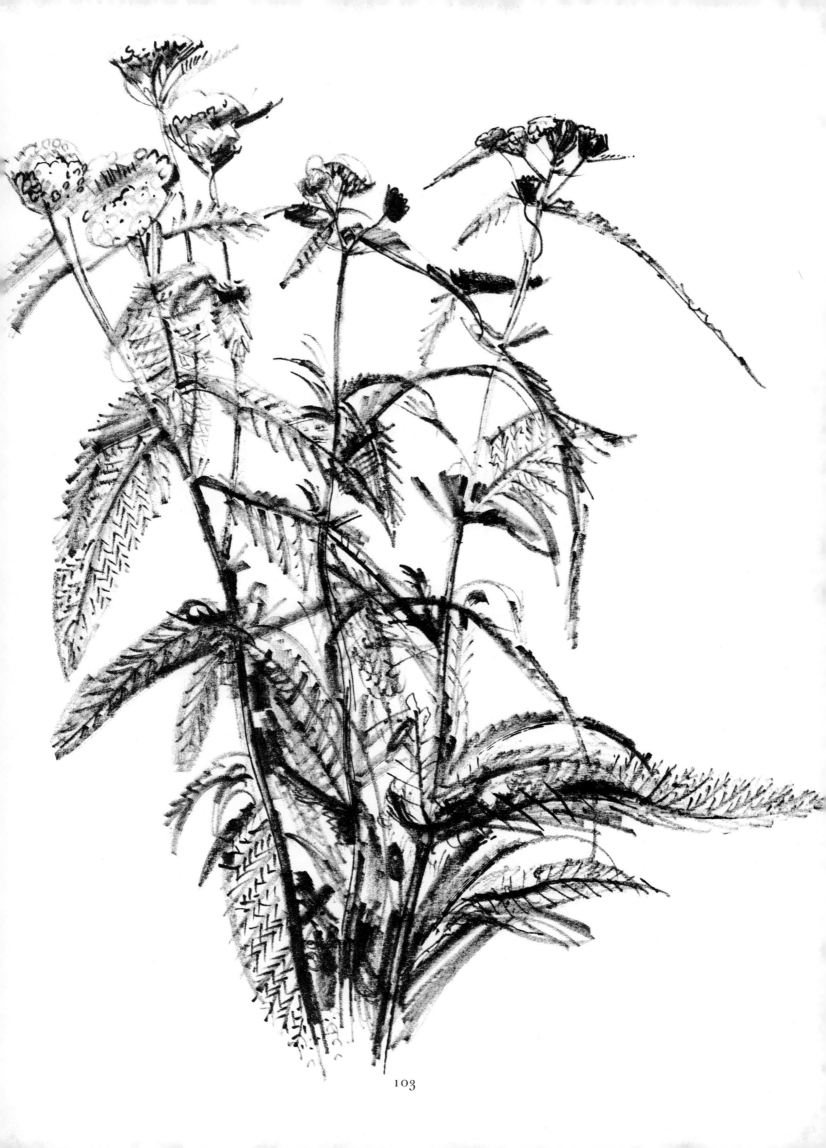

103

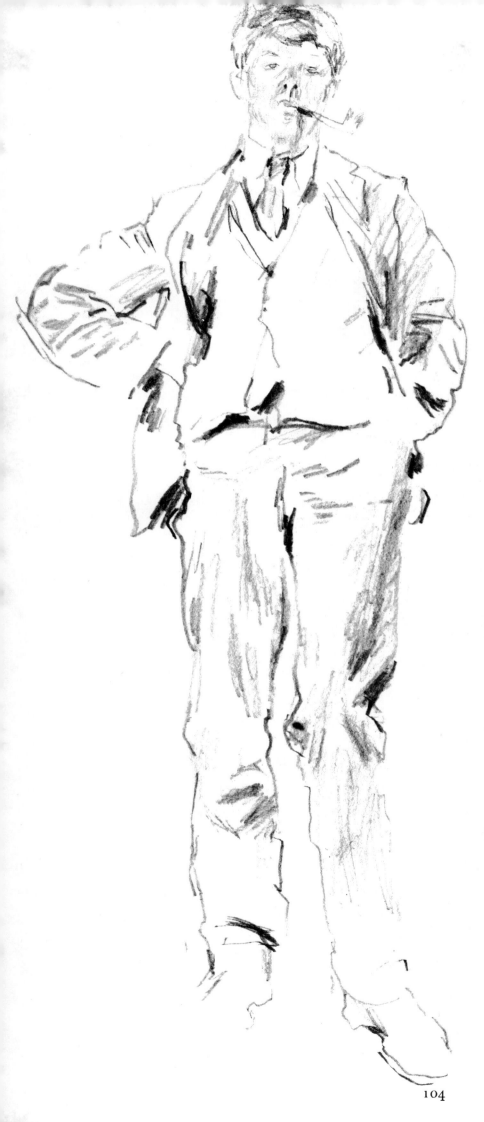

The whole burden of this argument so far has been based on the importance of training one's sight for the keenest observation. I am aware that it seems to stress the eye as the source of all visual information and even of visual memory.

We have discussed drawing as though we were in a life class and drawing from the model. I will try to demonstrate with drawings chosen for variety that the moment we dropped isolated studies and entered the realm of seeing pictures we were no longer bound by the formula of the classroom.

The figure of course will always be of major interest. It is constantly fascinating and of infinite variety, and the artist, I think, is primarily concerned with the human story. We have shown flower and plant studies not because they were in themselves beautiful — in fact I don't believe the word beautiful has been used — but because they had pictorial and visual interest that gave sufficient reason to wish to sit down and record them. There was no formula for the flower drawings, no one was urging upon us the study of plant anatomy or of botany. Our eye said they were good. What looked good we drew, and in drawing we tried to include or to ascertain what it was that had given the flower its original visual interest.

It is not very different from figure drawing — perhaps a different kind of rhythmic pattern, but one which has to be sought out with the same painstaking observation as with the model yesterday or the landscape tomorrow.

The plant studies shown here were not the first attempts by any means. It is surprising what confusion can result before enthusiasm is sobered by understanding. You think "here is a flower, a plant of Queen Anne's lace. We can draw it casually. If it isn't correct no one will know the difference." But one sees the difference oneself, and the eye absorbed in watching the plant suffers shocks of disappointment every time it lights on the drawing, sensing how far it falls short of the original. We end by putting it aside and starting afresh — this time with more penetrating observation, and slowly, perhaps only on the third attempt, and by unconscious emphasis here and elimination of discordant detail there, does it become even more real to us than was the original. When this occurs we know we are drawing. We know also that this has not happened by the use of eyesight alone, but by a subtle ability to edit and interpret that must have developed unconsciously. There was certainly not a decision to draw "in a manner" or to gain a preconceived effect. The result came naturally when we simply tried to draw the thing as seen.

It is also important to understand that when drawing directly from life or nature the recording instrument largely dictates what one sees. After some experience it will be noticed that the eye, if one allows it to, *sees* one set of facts if the medium is a point, and an entirely different set if it happens to be a brush. The mature artist becomes sensitive to this and will avoid "forcing" a medium.

The illustrations for this book were drawn in many media from pencil to charcoal. As a student I used pencil exclusively. I have never been happy with charcoal but it does have one great virtue. It is excellent for the bold statement which is possible of refinement later, and I advocate an original vigorous statement. No drawing ever amounted to much which was started tentatively and cautiously.

For many of these drawings I have used a felt pen. The firm softness of the point combines the qualities of pen and brush. In its usual form, it is excellent for the bold statement, but by carefully sharpening the point with a razor blade it can also be made capable of the greatest subtlety. I find it a delightful tool, but the eye must be accurate, for erasure and corrections are not possible. Also the ink so far available tends to fade on exposure to light. I have rectified this by making my own ink of simple printer's ink in a tube and a suitable solvent.

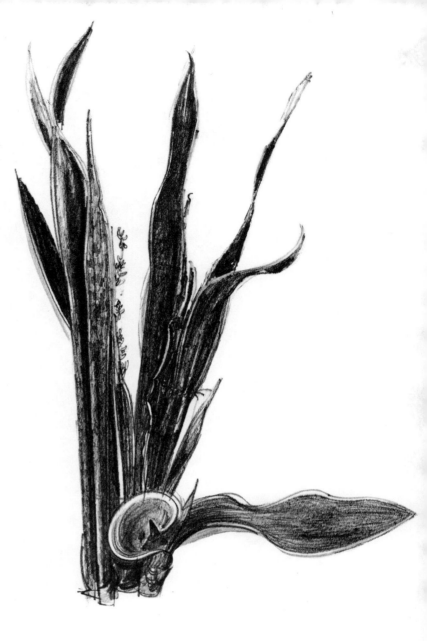

What it seems to come down to is that one draws in whatever medium is congenial, but during the period of training one should avoid those which produce impressive effects easily. If you are using a pencil and find yourself straining to put down what you see, you will not forget as quickly what you have seen and learned. All training involves a certain strain.

There is little more to say about materials except that when you draw for yourself you can use anything you please but when you draw for others, that is for publications, you often cannot.

If your drawing is for line reproduction you will use a line instrument and will draw in black for easy engraving. A line instrument, however, does not have to be a stiff, unresponsive metal pen. Anything which puts a line on paper is, I suppose, a line instrument, and I have not for years employed a pen. I much prefer a brush, and an old one at that.

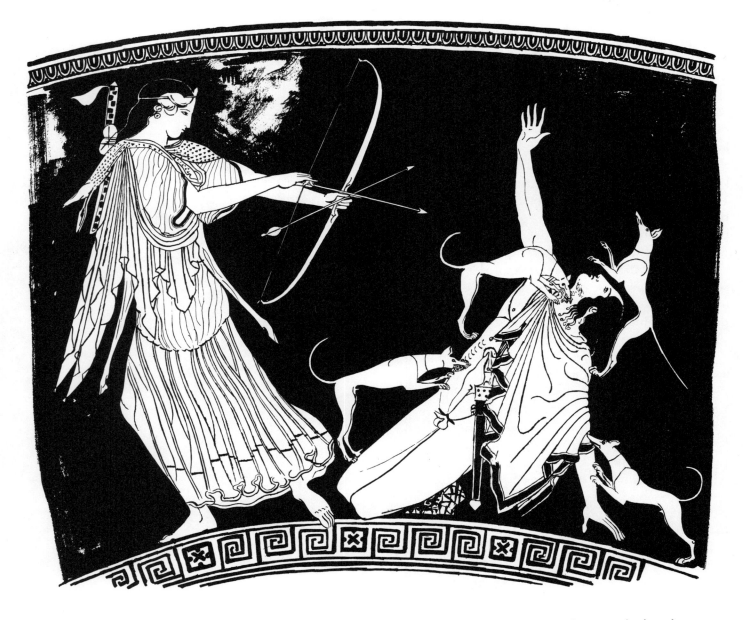

Death of Actaeon : drawing from a Greek vase : 5th Century

The study of Greek vase paintings is obligatory for the student whose chief interest is line. The convention is obvious, largely dictated by the brush, but the dramatic intensity is more than a simple decorative convention.

It is possible that the ancient Greeks in their vase paintings used a long-haired brush similar to what is called now a striper. A vase must have been a difficult object against which to lean the hand while drawing, and a brush such as this striper was possible of greater control. It also imposed a linear convention which in all probability had a lot to do with giving Greek pottery designs their special character.

But these are technical points which it is best to learn for oneself. In the comments on the basic theory which precede this, the less one thinks about materials (the means), and the more one concentrates on the realization (the end) the better. In pure drawing nothing should come between the artist and the idea, and I can think of no way of expressing the idea, however eccentric, which is not legitimate and acceptable.

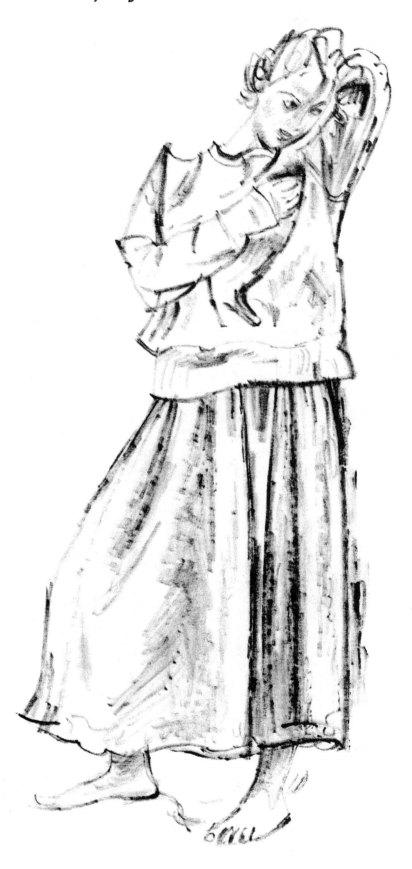

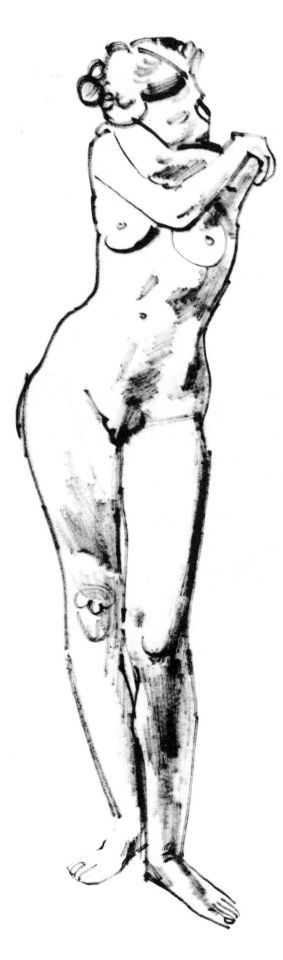

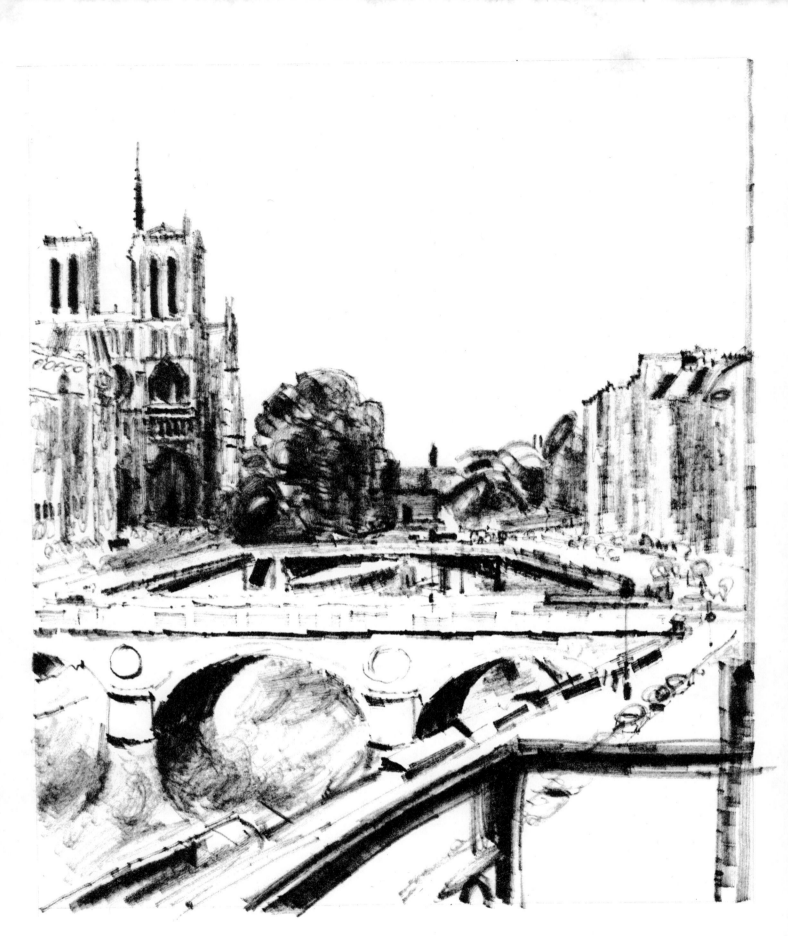

The medium largely dictates the observation.
In this and the opposite plate, drawn at different time
from the same window but with different
media, it is shown how this happens. The above
was drawn with a felt pen which can be made to
behave like a brush. The observations are tonal.
 The pencil drawing at the right is distinctly
linear and dry, almost astringent.

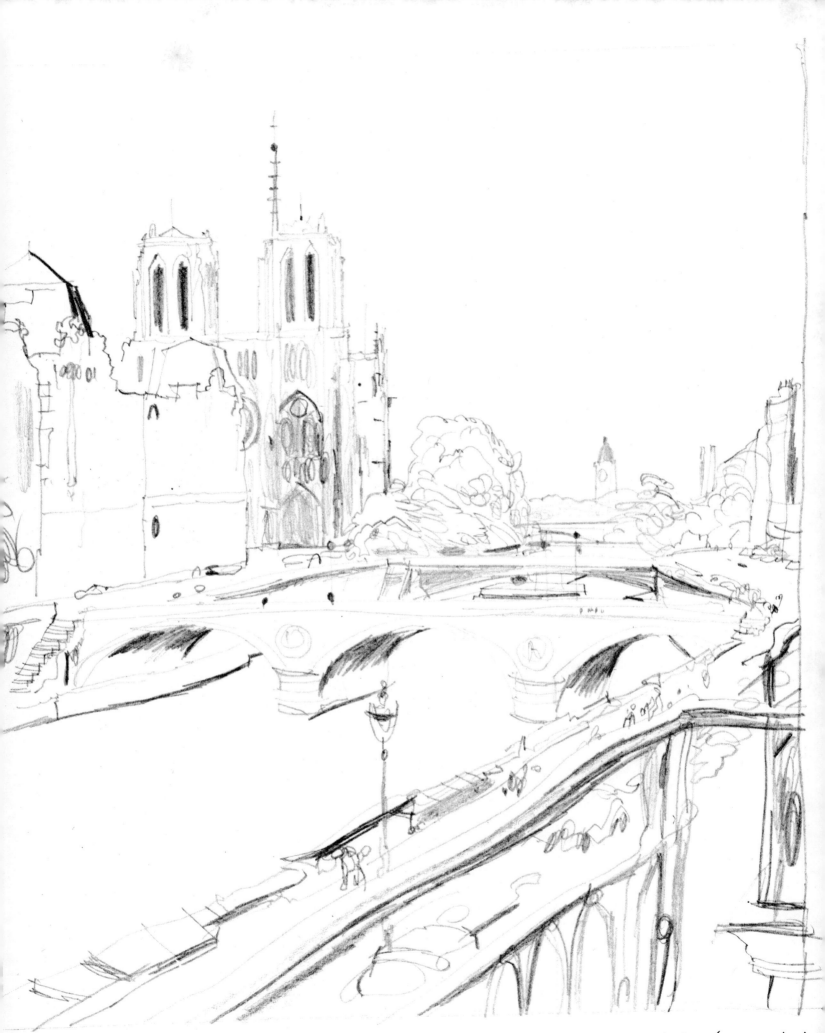

paris. view from hôtel window. pencil

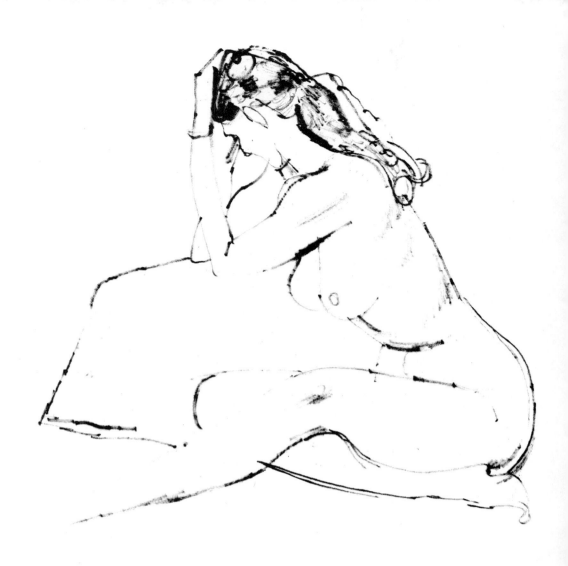

12. *Economy*

A good drawing may be described as proof that the thing seen is understood. A drawing done with a minimum of means can convey this and be just as complete as a highly finished one. But in most cases this is not likely except after long practice at sustained studies. If we are asked to explain something orally, and our knowledge is comprehensive, then we can, in all likelihood, sum up the explanation in a few concise phrases. If we do not fully understand the subject of the question, our answer will possibly be more long winded. That is the way it is in drawing.

But beware of the glib answer, either orally or graphically. One's study can be admired for its beautiful line, but if that line is not expressing an understanding of the form itself, it remains mildly interesting, but empty of content. I think it is more rewarding to take the time to listen to the involved explanation, even at the risk of being bored, if the thought is likely to be a profound one.

Economy is the result — the means are confidence and the facility born of long practice.

The time comes to forget all dicta and dogma, when one's drawings stop being the object of one's own criticism and become instead a spontaneous free exercise.

It is possible then to put down a line without asking whether it encloses a form, knowing full well that it will. The movement and quality of the line itself become a sensuous experience.

The artist can distort wherever fancy dictates and eliminate whatever is redundant. Subject matter becomes one's own choice and in all possibility it will be an entirely different choice than it would have been years eariier. The vision which was naïve is now sophisticated and rejects the commonplace, the pretty, and the popular. It has developed its own set of standards. Strangely enough much sophisticated drawing reverts to the naïve. The hand which has become sure, accurate, and precise, now

often engages in strange inaccuracies and even eccentric flights of fancy. It is all quite legitimate but is often unappreciated except by the equally sophisticated. These variations from the normal are not arbitrary, but are dictated by other needs. To achieve a sense of unity might suddenly seem extremely important, and if it can only be gained by breaking a few rules then the rules are broken without qualm.

Economy in drawing is essentially the shorthand which develops in the excitement of the fleeting moment. It is the thing seen subjected to editorial excision. What we spoke of earlier as the gathering and setting down of information is now radically modified by selection and emphasis.

Another quotation from Sir Joshua Reynolds seems particularly apropos at this time in a discussion of economy. Addressing the Royal Academy students in 1790 he said, "Let the power of a few well-chosen strokes, which supersede labour by judgment and direction, produce a complete impression of all that the mind demands in an object; we are charmed with such an unexpected happiness of execution, and begin to be tired with the superfluous diligence, which in vain solicits an appetite already satiated." In other words, "Brevity is the soul of wit."

Economy is usually exemplified by the use of the simple contour outline in place of the earlier highly modelled and textured studies, and if the relationship of the contours is justly contrived so that the enclosed area evokes a solid form, then there is no reason why additional emphasis should be given to its structure. Many of the finest draftsmen of recent times have used the simple contour with the greatest expressiveness, and with little or no interior elaboration of the defined shape. I refer to Rodin, Modigliani and Matisse in particular. But while in hands like these contour drawings achieve a unity which is a constant delight, it is only by a comprehensive knowledge of the form itself that they are able to do so. But care should be taken to differentiate between this quality of unity and the more commonly used simplification, which is too often an arbitrary reduction of form to a sterile, decorative end.

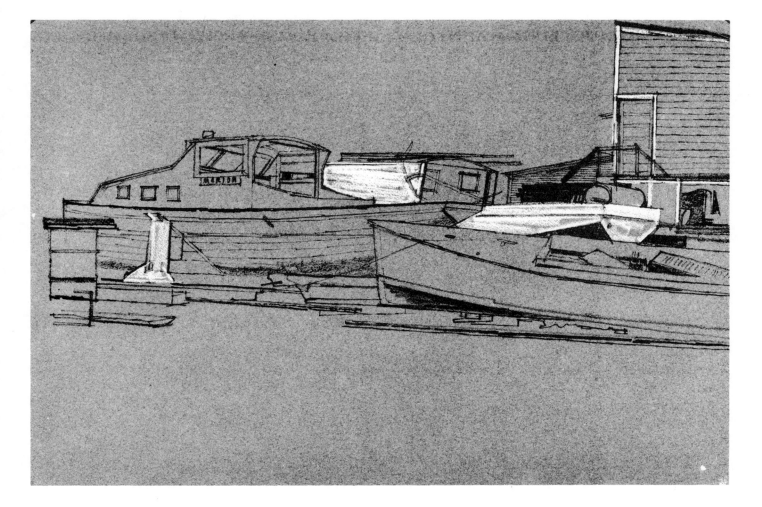

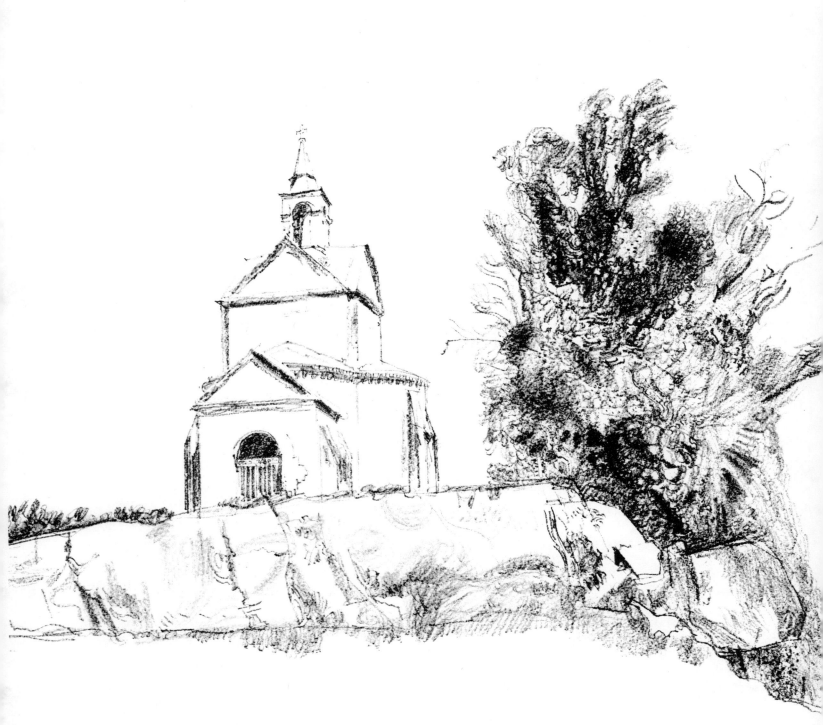

Chapel near Arles

But simple shorthand, which is a mannerism, is easily recognized and soon forgotten. It is more apt to occur when one feels himself in competition with those around him and one should never feel in competition except with oneself.

The simple outline drawing of the small chapel would have been arid except for the highly textured passage of trees beside it, for this drawing is also a quite simple, economical composition of *chapel*, trees, and foreground rock. Neither economy nor simplicity mean that the result should be arid or sterile. The drawing of a boat yard on gray, on the other hand, is a more contrived kind of simplicity. It is brought about by the distillation of an original drawing, sometimes by several redrawings, each time with a reconsideration, refinement, and elimination of detail. I don't say "contrived" in a derogatory sense necessarily, but only in the way that, as in the following chapter on the contrived picture, the result is brought about more by a conscious exercise of taste than by a more spontaneous and natural censorship of the moment.

For the word economy, which like so many others, we employ to describe what is, after all, an extremely abstract subject, has a way of becoming interchangeable with others. What we have just described as economy can be called simplicity, which is not always the same. There is that aspect of economy which applies to the seeing, a subject seen in completion, the total statement. The technical means used to reach this may sometimes seem far from economical in that sense. In the few examples which accompany this chapter are some which in parts are so highly textured that the word economy does not seem to apply correctly. In the small (reproduced almost actual size) drawing of the hillside at Assisi, topped by the church of St. Francis, I do not think the degree of texture in the hillside detracts from a basically simple statement. If different materials had been available that early morning I could as easily have stated it in three simple tones. Since I had only a point to draw with, and the texture was there, it was a case of adapting the means to the end.

So, economy, like every other aspect of drawing, resists absolute definition, and the subject is the better for it.

It is obvious that many seeming contradictions have taken place throughout this whole argument. Subjects have tended to overlap, and the subject matter of one becomes as applicable to another. The basic contradiction was that the discussion primarily pointed to a breaking down of categories, whereas the design of a book into chapters tends to create them. But at the beginning we learned that this might occur, and I am reminded how valuable was that part of my own early training at the Slade School, when the instruction was so diverse as to be contradictory. As students we were forced to choose, to digest, and to finally develop independent convictions. Those who did not became lost in confusion, those who did were the better for having weathered it. The best one can hope for is to have been stimulated into independent investigation, and perhaps into action.

Assisi

Illustration—The Contrived Picture

What follows is an attempt to provide proof of the validity of what has gone before. Without showing finished pictures, and, for the most part, displaying the preliminary studies, it is hoped to give a rationale to the blood, sweat, and tears of academic study. The final pictures for which most of these are studies, are merely amplifications of what is shown here. Some might have been in color, and many refinements were added, but the architecture of the pictures is, I believe, established.

We started by drawing the basic forms, in this case the human figure, isolated, taken from context. Later we showed that by drawing naturally, that is by "sight-size," many of the problems of this kind of drawing were eliminated. With these removed we considered what we were drawing *for*. The decision that since this was basically a preparation for painting allowed it for modifications of the original ideas. By seeing in the flat and drawing by light, we were able to include surrounding elements — to place the isolated form back into its context. It would have been difficult, in fact wrong to attempt this in the beginning, but the training of eye and hand now made it less formidable. It was a short step to the consideration of everything as a "scene," like a landscape if you will. Drawing the entire picture then became a natural development.

We should now be seeing things in terms of complete pictures, not necessarily good pictures, or even interesting ones, but still compositions within a frame. This is a long way to have come for the person who a year or so before thought he had to be concerned with the terminology of bones and muscles in order to learn to draw. Again I say that if the student did take the trouble to learn the difference between a gluteus maximus and a posterior spinous process, no time was lost. I did it myself, and although I reject it now, those who say it is still discernible in my own drawing may be right.

But you may have an exhaustive knowledge of all that and still be unable to compose a picture — and you may know nothing about it and be an excellent artist, in fact the latter is more likely. I hope this sounds less heretical now than it did earlier.

But now let us turn to a consideration of a different kind of picture — the "contrived" picture.

The illustrator rarely if ever finds his subject matter ready-made — as does, say the conventional watercolorist. The illustrator is given an assignment or a commission, and his picture is largely if not wholly contrived.

I use the word "contrived," which is accurate but which has unfortunate connotations. These pictures are contrived only in that they are imaginary. But the final result must not look contrived. It should have an immediacy that gives the viewer the impression that he is present at the actual scene, or at least that the artist was. By this I do not mean a photographic quality. The artist who understands this sense of immediacy can convey it with a simple line drawing.

The following examples, mostly of preliminary studies, are chosen at random, and selected largely for variety. Remember that I employ no mechanical

aids, because I resent it if any of the steps from first concept to finished picture are not subject to the censorship of my own taste, and also because my chief concern in these is the architecture of the picture, the rightness which holds things together and makes pictures easy to look at, and I have yet to see the machine which will do this.

When a picture is completed these preliminaries are usually thrown away, but since this book was contemplated I have saved a number of them. In them you see the illustrator off guard and sometimes floundering, but it is all part of the experience. I like to believe that the ability to *see* pictures which we demonstrated earlier is present now, that even though the entire picture is never actually there to be seen, it is still there to be imagined.

The muralist has the same problem, except that for him the sense of immediacy is not necessary. It is better that his designs remain aloof, that they first become one with the surrounding architecture of which they are a part.

But the architecture of a picture, the basic structure of an informal design, which is what a picture is, is difficult to define. Architects themselves refer to a "scheme," which seems to be the basic idea around which their building or structures will take shape. There are similar schemes in most successful pictures though they may be called by different names. Where it is not evident I will try

The first free sketch for what is to be a fairly complex design is more valuable if carried no further than this.

Confusion could easily result if one ventured into the painting before going through this stage, and surprises can be avoided by becoming thoroughly acquainted with the design beforehand.

For final guidance, only the minimum is traced down, and always with emphasis on the pattern. This allows for further improvization right up to completion.

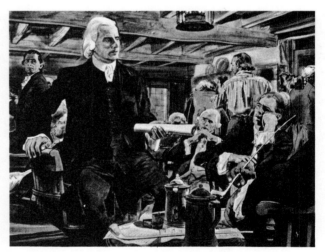

Where he walked, freedom grew...

STUBBORN Sam Adams had just one idea—that America should be free. He devoted his life to it.

You'd walk into a Boston coffee-house . . . a Salem town meeting . . . a Massachusetts convention . . . and there would be Sam Adams, off in a corner with John Hancock, Paul Revere, Joseph Warren. Speaking softly. Asking questions. Offering a resolution. Getting dockworkers, merchants, mechanics, printers, farmers to think about their inalienable right to be free and independent Americans.

Look! He told all of us, over and over again . . . *You are perfectly fit to govern yourselves.*

We listened to Sam, read what he wrote (under seventeen different pen names), and changed our mind about the divine right of kings. Tirelessly he exposed tyranny and corruption . . . argued with the timid . . . organized the machinery of liberty.

And if it crumbled—as it often did—Sam was always ready to pick up the pieces and start fresh.

He showed us how "committees of correspondence" in each colony could keep everyone informed on how the fight for freedom was going. And when Sam's express riders came thundering down the seaboard with news of how Boston harbor had been turned into a teapot, Connecticut farmers, New York mechanics and Virginia gentlemen caught Sam's independence fever . . . and things started to move.

No wonder King George quickly promised a full pardon to every American patriot under arms . . . "excepting only John Hancock and Samuel Adams."

For even across the ocean, it was clear that stubborn Sam Adams— like his friend Hancock—knew what he wanted . . . *freedom for America.* And he knew how to keep on fighting for it until it was won.

He'd like the way we've been fighting for it . . . holding on to it . . . ever since.

John Hancock MUTUAL LIFE INSURANCE COMPANY
BOSTON, MASSACHUSETTS

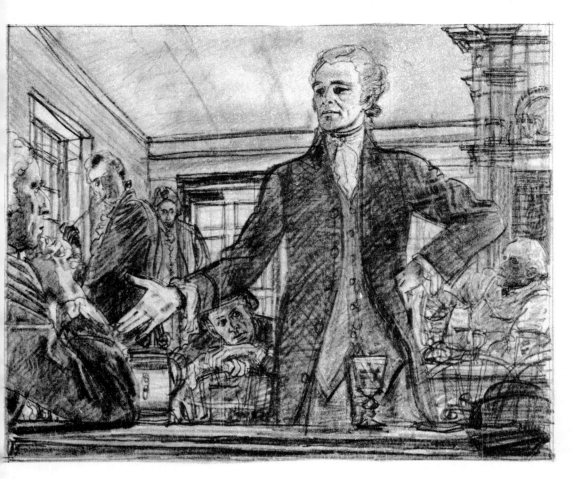

Preliminary drawing in pencil for an historic portrait

in a setting.
Preliminary drawing for an illustration.

to indicate the scheme or basic idea behind the following studies. Sometimes it will be hindsight, apparent now but not consciously understood at the time I was working. In others the basic scheme or compositional idea was one with the original concept.

At this stage, as you will see, I have not involved myself in details. These I leave until later. Objects for the most part are indicated as shapes with little attempt to articulate them, for at this time the space a thing occupies is substituted for the thing itself. Figures are sometimes indicated just as impersonally. I know what they will finally be, but at the moment I am involved in a game of fitting together a pattern or a jigsaw puzzle of my own devising. This does not come together mechanically but is always dominated by the dramatic idea. If the picture is to include several figures, parts of these may be eloquent, other parts less so. Since in working for publications the final printed page is a very expensive property, the aim should be to eliminate dead areas wherever possible, and in this way the picture gains in vitality. In much of my own published work it has been mentioned that I include everything but the kitchen sink, but if this is meant critically I cannot believe it is valid. The only criterion, I think, is whether the result is confusion or order. The reason I take

time to prepare a picture thoroughly is to avoid confusion later, and the simply calligraphy with which it is finally rendered gives an erroneous impression of ease.

If the illustrator reads his manuscript carefully he cannot avoid coming up with a concept of the best and most provocative picture to do. The trouble is that most artists do not immediately sit down and try to draw that concept. Instead, motivated by the desire for authenticity, they go forth with models to the locale the manuscript calls for, or a close facsimile of it, and from then on the original concept is forgotten. What follows is a gradual deterioration of "the idea," for the actuality is never quite as good as the imaginative picture. No landscape was ever as exciting as a good painting of it, otherwise there would be no need for painting. But authenticity, we are told, is necessary. I agree, until it starts interfering with the far better picture born of the artist's imagination.

I have done many pictures with Victorian settings and I am usually confronted with disbelief when I say they are largely if not wholly imaginary. The fact is that I am quite sure they are more Victorian than the originals ever were. With knowledge of what Victorian decor was like, and

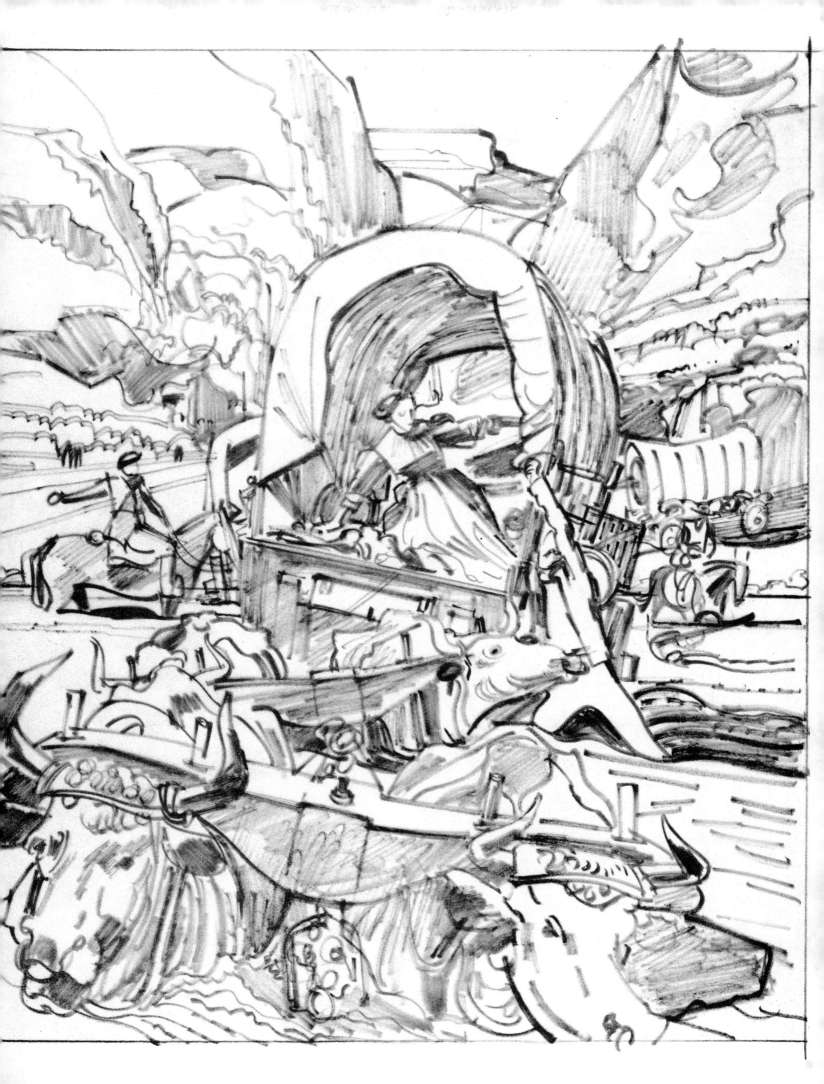

of the musty gloom of the average interior, combined with an understanding of the over-ornamentation and, to us, the bad taste of the latter nineteenth century, one can sit down and fabricate interiors, furnishings, and bric-a-brac to one's heart's content. If the question is ever put to me of authenticity (which, since I draw with conviction, it never has) I would only ask how could it be more authentic, since I made it up myself?

When the picture is contained in a simple rectangle the problem is relatively simple. We admitted a little earlier that the extension of drawing the isolated object to drawing the scene, changed what we were doing from acute observation and recording, to a consideration of relationships within a frame, and although the frame could have been round or oval, we chose the rectangle as being simpler and more usual. We are doing the same thing now — arranging components within a rectangular frame and for the greatest possible economy of space.

When the picture composes as an irregular shape, known technically as a vignette, the need to compose it tightly and solidly is just as great, or even greater. What makes the vignette work well is the feeling that it is a condensation of a complete picture in which what is omitted is supplied by the active imagination of the viewer. One too easily ignores audience participation as a part of making pictures, and what I have been talking about above is that by avoiding the actual delineation of inexpressive parts we invite the viewer to supply them. In doing this he participates in a way which adds immeasurably to his experience and pleasure in looking at pictures, and our visual message has avoided becoming long-winded and has become more precise, even provocative.

The rectangular picture frame is a convention. We make a mistake if we consider the vignette only as an incomplete or unorganized picture. It can and should be designed with the same care as the rectangle, and if back in the life class we had started to design as we drew, it should not be a difficult thing to do now.

A book like this should ideally consist of nothing but a collection of plates. If drawing is the eloquent language we believe it to be, then that should be our medium of communication and text should be superfluous. This has obviously not been the case here. But this is a textbook, and exposition and argument I believe had to be made.

One may ask why I believe drawing has to be

Preliminary sketch for a vignette.

Diagram of tight organization of sketch above.

championed. I believe it needs its advocates at this time because we have been going through a period which has failed to understand or has ignored the simple art of delineation. The superficial crudities of some contemporary painting has led to a confused feeling in some quarters that draftsmanship and painting are completely divorced — that all one needs to do is buy paints and canvas and plunge in. This may be all right for the amateur bent on a little therapy but I think that the time has come to redraw the line between amateur and professional.

I think the illustrative picture would gain if the artist first sat down and put his imagination to the test by simply drawing what occurs to him, to the greatest completion he can achieve, and only then, and if something seems lacking, should he resort

Preliminary plan for an illustration in which no figures appear, but are suggested by an approaching shadow on the walk.

The minimum of middle
tone was necessary to
anticipate those passages
which needed clarification.
The solid black under-
drawing continued to carry
the design, and little was
lost in reproduction, which
in fact was on newspaper
stock.

A design started tentatively rarely gains in
vigor later. In anticipation of the dilution, which
we know would take place, the first rough
draft was put down with an almost savage
intensity to match the subject matter.

As the drawing became particularized some
of the intensity of the original sketch was modified,
but enough still remained. The modeling
is by light, designing by shapes made
by light playing on the forms and on the scene.

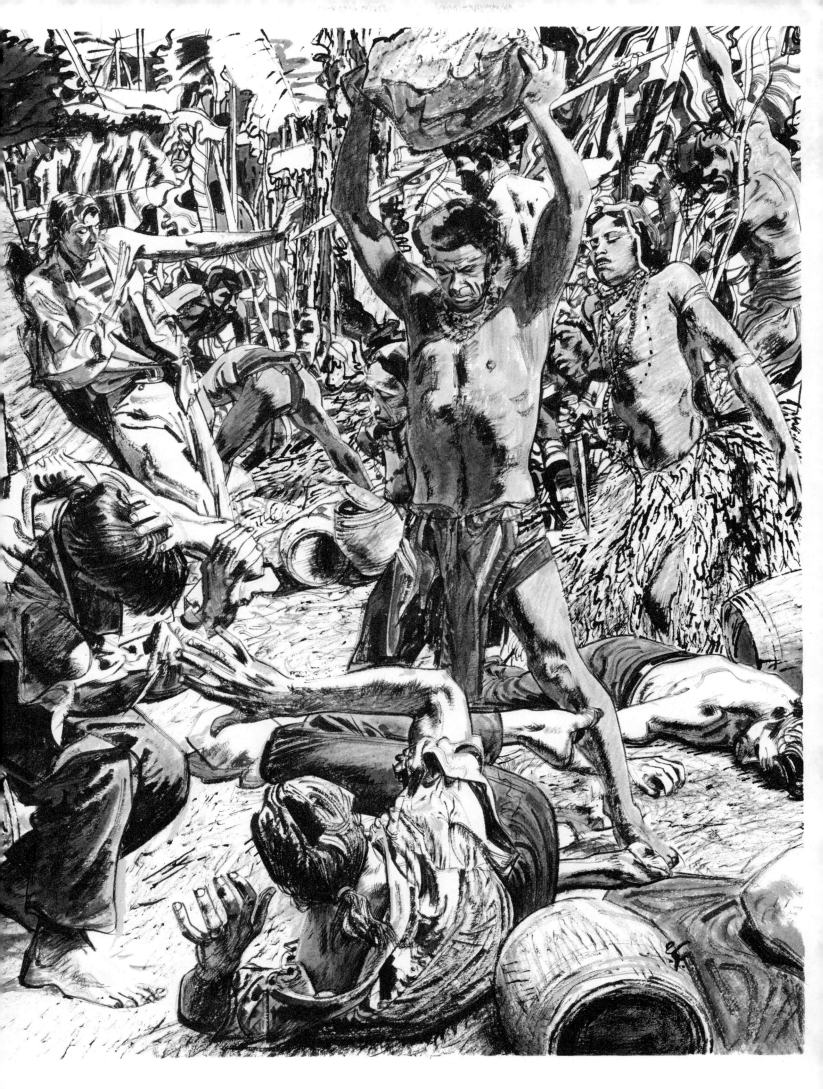

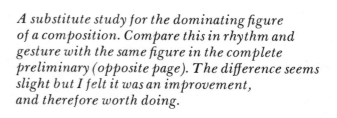

A substitute study for the dominating figure
of a composition. Compare this in rhythm and
gesture with the same figure in the complete
preliminary (opposite page). The difference seems
slight but I felt it was an improvement,
and therefore worth doing.

to research. Many would be surprised to find that they have retained more visual impressions than they ever thought possible, and what is more, the picture will have more of the stamp of individuality.

No tracing of a photographic image ever has the life and vitality of the actual subject freely observed and drawn. No one will deny that photography has become a valuable reference, not only to the illustrator but to the painter. I recall an incident of some years ago when a painter was called to account after it was disclosed that a work of his had had its inspiration from a published photograph, as though this was dishonest! What nobody seemed to point out was that from this initial prompting he painted a picture which had a plastic reality the photograph never had. It was doubtful whether he consulted the photo again after the first hour — the weeks which followed were an intimate communing with himself and the canvas in a concern with values understood only by a painter of sensitivity. But through all this a vague similarity of subject matter was still recognizable and he was jumped upon by some who seemed to confuse amateur sleuthing with aesthetic appreciation. My disagreement is not with the use of photography as a stimulant or as a source of research, but with its use as a means to an end which too often falls short of the original photograph.

I have urged that the student pursue the training of eye and hand as though mechanical aids did not exist. I guarantee that if he does this he will later reject them from preference.

Illustration is an art form which I respect. I believe illustrators who do not give it their best endanger themselves more than the art itself. I fail to see how artists can slough off work which has an avid public of millions every week. A popular art does not have to be a vulgar one, and the public will accept and enjoy far better work than is at present being offered. I have been guilty of one aspect of this snobbery, myself. I originally adopted a simple initial signature in an effort to remain anonymous in the periodicals. I hoped thus to avoid any stigma of commercialism which might be embarrassing later when I exhibited paintings. I was fooled on both counts. My initial signature became publicized to an extent that I was soon being greeted as 'R.F.', and as far as exhibiting

Preliminary drawing (left) before changing the main figure, and (right) the final picture.

125

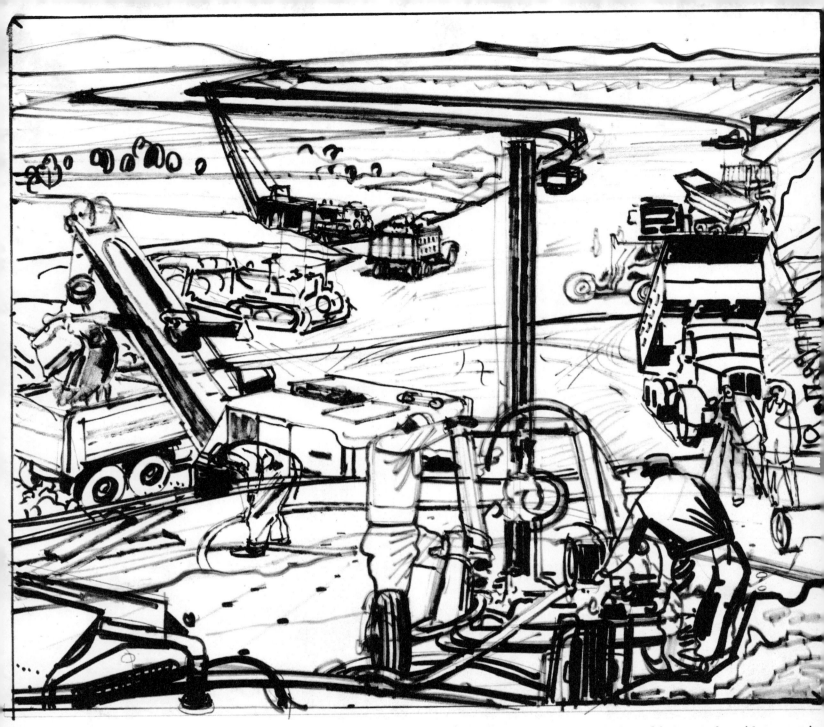

Although it is still technically drawing, this cannot be said to contain any element of beauty. It was not meant to. It is simply a crude spacial plan disassociated from any aesthetic purpose. One has an aptitude and is using it for purely utilitarian reasons — in this case to push into arrangement or composition many elements which must have an almost literary appeal.

paintings is concerned, it would not have mattered one iota either way. I was bringing from Europe a prejudice which in America was unknown. I was motivated by snobbery and by an acceptance of that line between "fine" and "commercial" which I now reject, and I have since tried to devote to illustration itself a serious application which I believe it

warrants. There are limitations imposed from without, it is true, but within there is more freedom than many illustrators are prepared to explore.

One limitation is technical: It is to produce a picture which will excite reader interest. The illustrator starts as handmaiden to the writer, but in many cases, and through no fault of his own,

he ends by dominating what started out as a cooperative effort. This is understood by the publishers, who spend time and money in the search for new illustrating talent.

Another technical limitation is reproduction. A picture for an illustration is finished only when it appears in the book or publication. If it does not look well then, it does not matter how it looked in the artist's studio. Nothing is gained by blaming the production man, a popular practice of illustrators. It is far better to draw in a way which will be foolproof — even if the shop leaves out a color.

Perhaps the most rigid limitation is the one most difficult to explain. It stems from the general appearance of the periodical, which demonstrates graphically the preferences of its art director and its editor. It is the illustrator's duty, if he feels artistically at odds with them, to try to circumvent this last barrier. Unless he does, he will soon find himself imitative and tentative, for their standards are almost invariably the safe ones, which means what the competitors are doing, and his work will only add to the general mediocrity. When this happens, the people he is trying hardest to please will stop using him. With tactful stubbornness, he may succeed in selling his work largely uncensored, and then both he and the periodical will profit. I agree that drawing for periodicals should be a cooperative venture, but I cannot believe that cooperation is served by bowing to every prejudice of the timid.

I do not think the illustrator will find much guidance or inspiration by frequenting (especially the modern) art galleries. I have never considered that painting and illustration had much in common beyond the similarity of materials employed. This is not quite so true when what is technically illustration is a simple representation of objects. But when true illustration of text is called for I think the illustrator can find greater inspiration in the theater, preferably the live theater, but also in the better motion pictures. The theater deals with drama, comedy, and all the human emotions as does the illustrator. The theater has both interior and exterior sets, which it furnishes with props and characters, and it is in these settings that the drama unfolds. In addition, the action is enhanced by lighting, constantly moving and changing as the scene varies or as the dramatic tensions develop. How similar this all is to the illustrator's problems. I wonder why illustrators who so often are heard discussing the latest avant-garde paintings of Picasso are not instead studying the techniques of the Elia Kazans. For what is a good illustrative picture than an imaginative, inspired still, a synthesis of what has gone before and a promise of what is still to come. Do not confuse this with the average still photographs outside the playhouse, which synthesize nothing and are simply factual records of different moments in the drama going on inside.

In the first sketch at the right the drilling machine at dead center was vetoed, but not by me, and the final drawing (above) grew from the preliminary at the left.

Beethoven composing at the pia[no]

I think my own greatest influence in illustration was not only the live theater, but opera in particular. It may be difficult to understand how the stilted, formalized gestures and movements of the average opera singer contributed much to a career in which the word theatrical is not always a complimentary one, but I am sure that the slow unfolding of the drama, with action, music, and lighting all working in harmony, did help to develop the ability to envision a total scene from a manuscript.

I said earlier that I reject the words *fine* and *commercial* as applied to graphic art. As generally used they have connotations not only of snobbery but also of acute artistic schizophrenia. I do believe, however, that it is possible to be both an illustrator and a painter, and one needs only to recall Honoré Daumier as a classic case in point. There is no reason why a competence in the use of materials in one profession should not carry over into another, unless of course the hand has been vulgarized by indulgence in meretricious tricks which it is unable to discard. In Daumier's case he used lithographic crayon and stone to do what were some of the finest humorous drawings of his day, and which are prized by collectors now. When he painted he turned to oils and canvas, so the physical difference was more apparent. He was also then motivated more by aesthetic considerations than he was in the more utilitarian delineation of his everyday work. Daumier may be proof that it is possible, but the rarity of Daumiers indicates the likelihood is improbable — it would seem to be more because of the limitations of human energy than anything else

But a short discussion on the value of photography in illustration is pertinent here. As an illustrator I am all too conscious of the way photography has been abused, to the point where many illustrators are afraid to put pencil to paper without first photographing their subject exhaustively. Too often, as a result, they allow photography to use *them,* instead of them using it, in the way they might use any of the other studio materials.

Photography has been in use by illustrators for many years. That it will continue there is no doubt. This being the case, the best we can do is to examine the medium, see what it can legitimately accomplish, and note where abuses have occurred. In doing this we may clear the air and so help find photography's proper place.

One of the most legitimate reasons for using photographs is that it allows the artist to observe action which is absolutely impossible to study without it. We can of course invent action, without such observation, but even with photographs, so much should be invention anyway that it is perhaps better if one starts by observing something which has a basis in fact. The camera can stop action — the artist, after observing its character, should *start the action moving again*. This so many fail to do. Observe the numerous cases in which what appears in the books and periodicals is so obviously a photographic image, the flying drapery so frozen at a two-hundred-and-fiftieth of a second, that one can almost see the flashlight go off. The illustrator is here at fault, not the camera.

A second reason for the use of photography is to draw upon the fund of information it can supply. The model can be posed in many variations of the basic attitude, and under varying light conditions, all in the space of a comparatively short time. As informative material the artist has a hundred times greater choice than if he had made studies, or worked directly from the model. This last way of working is limited by the model's ability to hold an easy pose for long periods, a condition which in itself would tend to create extremely static illustrations. In the end the illustrator would have had no alternative but the one pose he decided upon days before.

I have observed that illustration is more akin to the theater than to painting and the value of lighting for dramatic effect in both the theater and in illustration cannot be overestimated. Photography can capture this in a way nothing else can equal. Imagine, if you will, a model sitting for hours under the hot lights necessary for a particular dramatic situation, perspiring and uncomfortable (and incidentally running up a bill for fees perhaps out of proportion to the job in hand). In regard to models, the artist in industry is in competition with the photographer in more than one sense. Model fees are high, but the photographer can get his results in an hour. Economically, photography as an aid to the illustrator is necessary if only to allow him to compete on more or less equal terms.

But there are dangers, and these must be noted. The chief danger is the way photography can inhibit the concept right at the beginning. It does this by limiting the artist's imagination to only that which is capable of being photographed. It is a real danger, which too few realize because they have never put that imagination to the test. It has atrophied from nonuse. By scribbling freely in the way I describe in this chapter (which while not drawing in the best

The first conception of an illustration like this involves a mental picture of the completed picture in the publication. All subsequent design then stems from this.

Illustration - Case History

Isolating the picture area. It is interesting to note how closely the first rough scribble came to anticipating the final picture.

Many random ideas intervened, and these were jotted down. Some proved fruitful, others were rejected.

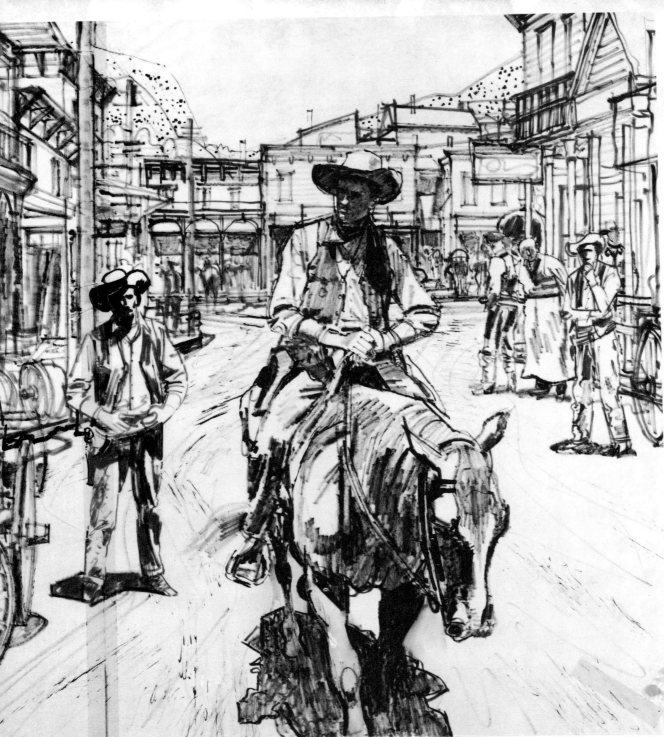

ove is the final draft, which is still only an elaboration of the
t rough sketch. What was originally conceived as the pattern of the
r-all spread, is now reduced to the pattern of the picture area
lf. Since the manuscript set the time as midday the source of light
irectly overhead, and all drawing is with this in mind.
pattern by light as described earlier, thus achieving the effect of
dday heat, one important mood of the illustration.
the right is the final drawing.

sense, has its basis in the *ability* to draw), he will begin to exercise his imagination. Remember the earlier quote from Sir Joshua Reynolds, "I very much doubt whether a habit of drawing what we see will not give a proportionable power of drawing correctly what we imagine."

I would have liked to have avoided this discussion of photography in a book devoted to the purer aspects of drawing. We have investigated the subject up to now on a plane which makes this present discussion seem out of place. But it would have been artificial to have ignored it, especially since even many painters employ photography these days. Another of the best French painters of our time did not even trouble to take his own pictures, but painted largely from post cards bought at the local shop. And this was a fine painter, whose pictures, although they might be characterized as picture post-cardy in subject and concept, were never photographic. He used them simply as a point of departure. One has only to look at the daubs of many of the outdoor painters around Paris to wish some of them would do the same, that is, take a group of post cards of the subject they are so laboriously and uncomfortably copying and start improvizing from there. Improvization is an act of the imagination, and is therefore preferable to copying.

One other use of the camera, and it seems to me legitimate, is for the gathering of so-called candid material for documentation—this material which will not remain still and submit to prolonged observation, such as the busy street, or the waiting room of the station. In fact the sense of movement may be the essence of what the artist desired to document. By doing this he not only captures a sense of the immediacy at the scene, but later examination may reveal pertinent details of the locale which memory alone would never have supplied. The camera is used here to support the memory. But the word *candid* which we used, is one associated with the camera, and it is also a quality of which I think the artist should beware. Although photographic drawing is commonly associated with highly polished and minute detail, its presence may also be noted in the most freely painted, or highly stylized pictures, when it is revealed by a camera point of view.

I have listed what I think are some of the legitimate uses of photography and pointed out some dangers. I add that the real draftsman is much less likely to fall into the pitfall of being used *by* the camera, and his result will have little if any resemblance to his source material. That will become dissipated in the exercise of his own resources.

So much, I think, for photography. There is no

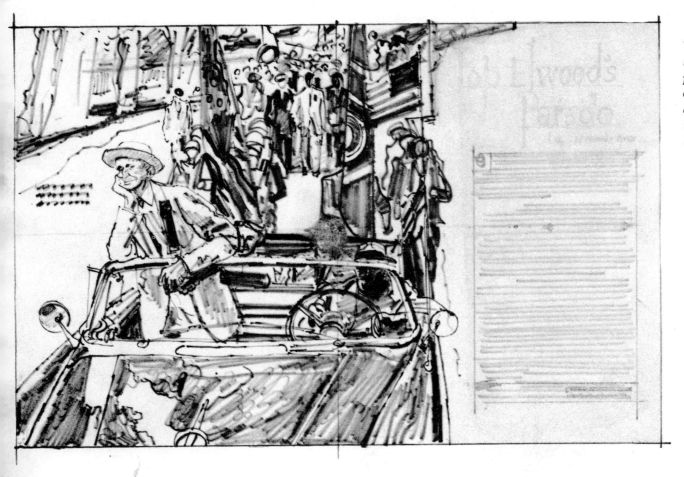

This preliminary, and that on the opposite pa, point up the psycholog of illustration more tha draftsmanship. But illustration is a literary art.

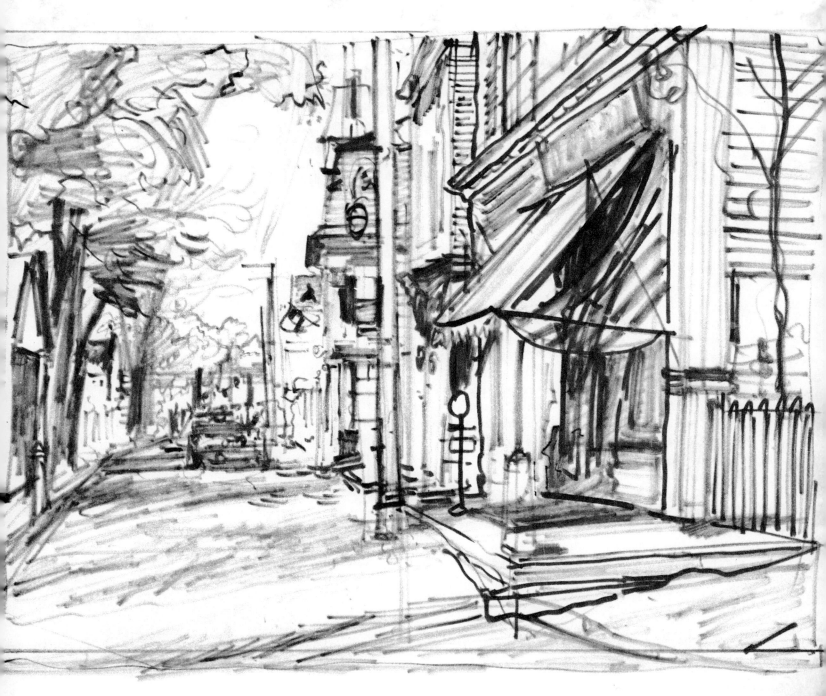

Preliminary sketch for a picture depicting a parade down an otherwise deserted small town main street. The first placed emphasis on the parade itself and on its chief character (opposite), but editorial decision changed this. With the parade approaching in the far background, what we conceived as a situation picture became a landscape instead.

contradiction here with anything we have discussed up to this time. We talk about it now simply because this chapter on illustration is about an applied art form, graphic art for industry. This is an entirely different subject, with its own conditions, its own taboos, its own peculiar problems. Most European schools devoted to fine arts shun this subject, while many American schools include elaborate courses on it. The European idea is, I think, commendable but

unrealistic. The American way is typical of a society which places too little value on abstract learning, and which puts too great an emphasis on practicality.

I place no particular halo around the head of the illustrator who "never uses photographs but draws everything out of his head." His drawings usually look it, for he too often falls into that trap of drawing by formula, an act of memory which we described earlier. It is a clever accomplishment, but only holds

interest for a short while. The only criterion should be the final result: has it vitality or has it not? To chide a man for the legitimate use of any means would be like criticizing him for employing one kind of paint over another.

As to the use of projection machines, except in exceptional cases when a complicated design must be mechanically enlarged, I have said the draftsman should, and will, if he is wise, ignore them. From my own observation they are more trouble than they are worth, a statement which I know will have not the slightest effect in reducing their extensive use.

Young illustrators will not find guidance by studying the currently popular. The popular is usually just on its way out. Neither will they find it by frequenting the galleries in search of new "techniques." The cause of illustration is best served by the artist who gains dignity by seeing himself as a member of a profession which dates from the time of Albrecht Dürer. He should know that to be a fine illustrator, he should be a person of growing culture and be devoted to an art form which always demands a finished technique in the best sense.

The mature painter knows that obscurity is not synonymous with profundity, and a portraitist knows that his work is no less good because his sitter's more complimentary aspects are included. Also the muralist, however much imbued with social consciousness, knows that posterity will evaluate what he does for entirely different reasons than the social or spiritual message of his design. (This is not to say the mural suffers by the presence of such elements, only that Michelangelo's Last Judgment can today be as much admired by a Chinese, although a Chinese would never have commissioned it originally.)

Likewise, the contemporary illustrator does not suffer by being realistically aware of his position as an illustrator in our society. Nothing is to be gained by indulging in romantic or unrealistic notions. If he is a picturemaker for hire, so were all the great artists of the past and he is in excellent company.

To any illustrators who feel they need bring little originality to the work they do every day, but spend their week ends in spurts of furious "good" painting, I would say I could wish that just a few of the noble ideas they are exploring on week ends could find their way into their published everyday work and thereby help to raise the standards of illustration instead of being reserved for the few or left standing face to wall. Others I have known have tried to excuse their casual attitude toward illustration on economic grounds. Pursue the line of least resistance in this, they say, and save one's energy for more worthwhile pictures once economic security is attained. This is to argue that a life of virtue is possible only if it is preceded by a short, profitable period of prostitution!

One who illustrates should give it his best. His stature as an artist is beyond his control, so he will be the better for not pondering too much about it.

But the technique of his craft is not only under his control, it is also possible of development, so the wise worker will concentrate upon it. If he fails to reach out and develop as an artist, if he remains a technician that, of course, is sad, except that I cannot feel that he would have been a better artist with less craft.

It is in the belief that draftsmanship, or good drawing, will always be the basis of the artist's craft, that this volume is offered.

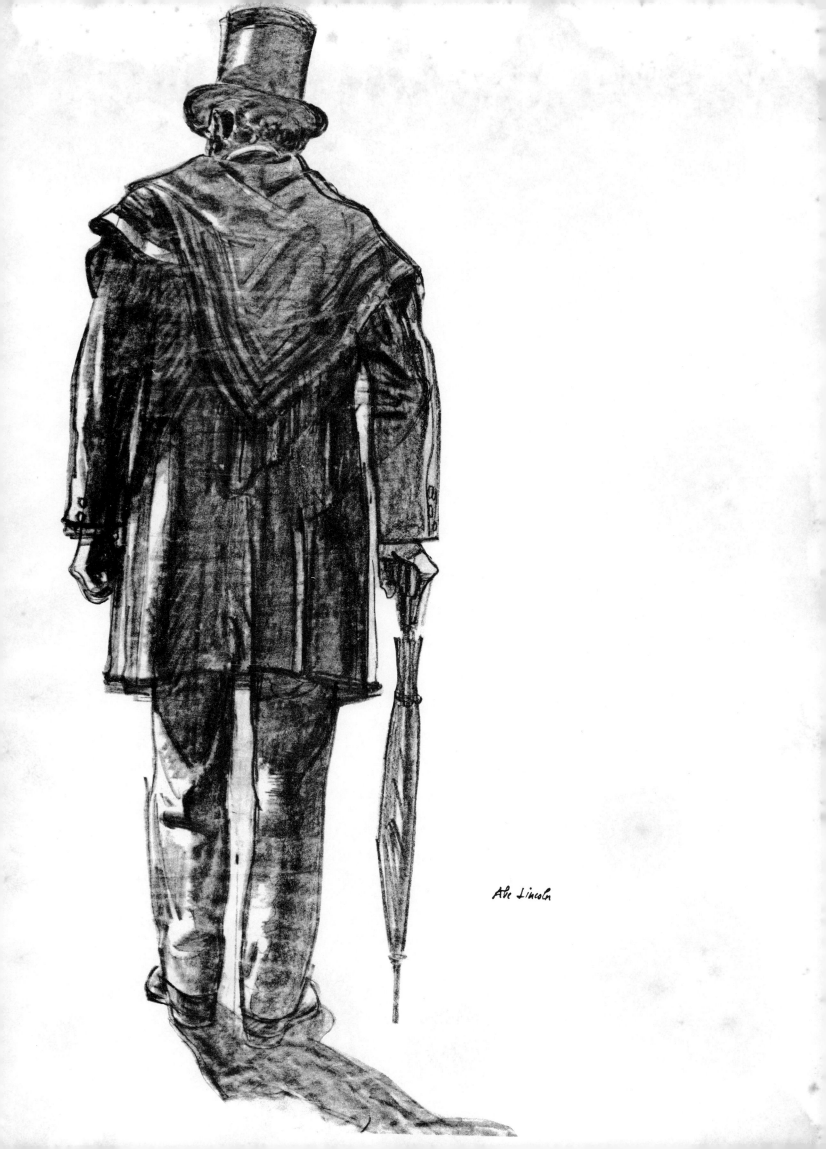

Abe Lincoln

ACKNOWLEDGEMENTS

I owe a debt of thanks to the following: To Samuel Grafton, for his help in editing an
inadequate manuscript, to Stephen Bone, Richard Murry, and James Fitton, R.A., of London,
former fellow students, whose suggestions have been invaluable. Also to the Arts Council of Great
Britain for permission to quote from *The Art of Drawing,* by the distinguished draftsman
and scholar, the late Bernard Meninsky.